Big Eyes: The Screenplay

Scott Alexander & Larry Karaszewski

———— • ————

Scott Alexander and Larry Karaszewski met as freshman roommates at USC's School of Cinematic Arts. On a whim, they wrote a screenplay during their senior year, which sold a week after graduation.

They are best known for writing very unusual biopics with larger-than-life characters. They first worked with Tim Burton on the highly acclaimed *Ed Wood* (1994), for which they were nominated for Best Screenplay by the Writers Guild of America. They followed this with *The People vs. Larry Flynt* (1996), for which they won the Golden Globe for Best Screenplay, as well as a special Writers Guild award for civil rights and liberties. They also wrote the extremely postmodern *Man on the Moon* (1999), the life story of Andy Kaufman. All their biopic scripts have been published in book form.

Otherwise, Alexander and Karaszewski are quite eclectic. They wrote the hit Stephen King adaptation *1408* (2007). They produced the Bob Crane biopic *Auto Focus* (2002), and they wrote and directed the comedy *Screwed* (2000). They have also written numerous family films, including *Problem Child* (1990), *Problem Child 2* (1991), *Agent Cody Banks* (2003), and the upcoming *Goosebumps*. Their next project is the ten-hour miniseries *American Crime Story: The People vs. O.J. Simpson*, which will air on FX.

Big Eyes

Big Eyes

THE SCREENPLAY

BY

Scott Alexander & Larry Karaszewski

—— • ——

VINTAGE BOOKS

A DIVISION OF RANDOM HOUSE LLC

NEW YORK

Contents

Big Eyes

FADE IN:

TITLE SEQUENCE:

TIGHT on TWO PAINTED EYES. The pupils are impossibly wide. Imploring. The watery rims spill a single tear.

We PULL OUT . . . revealing that the eyes belong to a child. A young girl, fingers clasped pitifully. She's forlorn, alone in a dirty gray alley. We feel shame. Compassion. Sorrow . . .

Then—an IDENTICAL girl SLAPS in front of the first one. Then another! It's a PRINTING PRESS, the creation of a BLUR of sad children.

A KINETIC montage! HORDES of gazing WAIFS get lithographed, bundled: Huddling in worry. Floating in space. POSTERS. POST-CARDS. BOOKS.

We ZOOM into a MAGAZINE AD: A 1960s era come-on—"IT'S KEANE! MUSEUM-QUALITY ART, MAILED DIRECTLY TO YOUR HOME!"

A blizzard of NEWSPAPER ARTICLES: "Meet America's Million-Dollar Painter!" "Keane Masterpiece at World's Fair"

Painted EYES float by. Haunting . . . Questioning . . .

Old POLAROIDS: A family Christmas, a Keane print over the mantel. Kids play bumper pool, a Keane print in the b.g.

A blurry black-and-white TV: A talk show HOST holds up a Keane painting—

MUSIC BUILDS. FASTER. Keane brochures. Catalogs. A flyer: "Now Open! Keane Gallery"

MORE orphan's faces. Hungry, unblinking, beseeching.

A CRESCENDO — then — SILENCE.

A single CARD on black:

> "I think what Keane has done is just terrific. It
> has to be good. If it were bad, so many people
> wouldn't like it."
>
> — ANDY WARHOL

CUT TO:

EXT. SUBURBIA — 1958

A nice, orderly tract of post–World War II housing. Identical rows of little yards. Young MOMS. Scampering KIDS.

Then, a SUBTITLE: "TEN YEARS EARLIER"

INT. HOUSE — DAY

CU on two concerned eyes. The same eyes as the paintings. We REVEAL that they belong to a real girl: JANE, 8. She sits in her small house — a typical young family's, spare and underfurnished.

Suddenly — Jane's mother, MARGARET ULBRICH, 28, rushes through frame. Margaret is blonde, yearning, fragile. Terribly upset, she is hurriedly packing.

Margaret throws her clothes in a suitcase.

She shoves Jane's clothes and toys into another.

Margaret barrels through the breakfast nook, which is a mini art studio — easel, canvases, paints. She scoops up her supplies.

— ● —

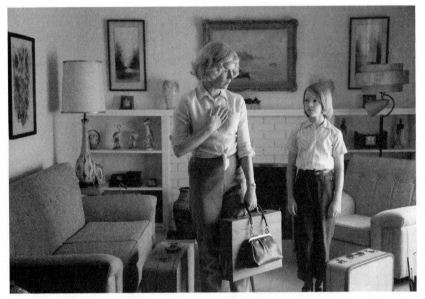

Margaret Keane and her daughter Jane leave 1950s suburban life.

— ● —

Margaret runs to the door—then turns. The hallway is lined with her PAINTINGS. Oils and inks of wide-eyed Jane, who grows from baby to toddler to child. Hastily, Margaret takes them down, each frame leaving an empty mark on the flowered wallpaper. Finally she reaches the last spot—a WEDDING PHOTO: Margaret and her HUSBAND, smiling, happy.

Margaret peers—then leaves it hanging. The door SLAMS.

CUT TO:

EXT. HIGHWAY — DAY

Cars roar down an interstate.

INT. PACKARD — DRIVING — DAY

Margaret grips the wheel, uncertain. Jane stares. The car is all loaded up. REFLECTIONS of passing BILLBOARDS drift across the windshield. Images of perky, happy-fake Americans.

Margaret bites her lip. Has she made the right decision . . . ?

CUT TO:

EXT. SAN FRANCISCO — DAY

San Francisco, 1958! A mix of SKYLINES and STOCK FOOTAGE.

EXT. FURNITURE FACTORY — DAY

A weathered building: G & B FURNITURE SUPPLY. Margaret sits in the Packard, fixing her lipstick. Jane holds the WANT ADS, a few circled. Margaret gets out and straightens her skirt. Jane smiles.

JANE

Good luck.

INT. FURNITURE FACTORY — DAY

A beaten-up industrial office. Margaret sits anxiously, watching the BOSS, a tired guy in a cheap suit. He glowers unsurely at her JOB AP-PLICATION. Scratching his face. Hmmmm . . .

> BOSS
> We don't get many ladies in here. So your husband approves of you working?

> MARGARET
> *(quiet; a soft Southern lilt)*
> My husband and I are separated.

> BOSS
> *(shocked)*
> "Separated"?

A deadly silence. He squirms uncomfortably.

She presses on.

> MARGARET
> Sir, I realize I have no employment experi-ence . . . but I sure need this job. I have a daughter to support.
> *(pause)*
> I'm not very good at tooting my own horn . . . but I love to paint, and if I could just show you my portfolio . . .

He is baffled. Margaret pulls out a large ARTIST'S PORTFOLIO. She opens it, riffling through the pictures . . .

> MARGARET
> I studied at the Watkins Art Institute in
> Nashville, then took illustration classes in
> New York. Here's a pastel I did . . . here's
> some fashion design . . . a portrait in char-
> coal . . . though I enjoy mixing mediums,
> preferably oil and ink . . .

She's alive, enthused.

The guy shakes his head.

> BOSS
> You do understand this is a furniture
> company?

CLOSEUP — MARGARET

A strained smile.

INT. FACTORY FLOOR — LATER

Margaret works on an enamel baby crib. Under stenciled "Humpty Dumpty," she quickly paints on a cartoonish egg man.

We WIDEN, revealing ten identical, completed cribs behind her.

We WIDEN again—revealing a DOZEN PAINTERS. All surrounded by identical cribs. All painting identical Humpty Dumpty's.

CUT TO:

EXT. SAN FRANCISCO NORTH BEACH — 1958 — DAY

NORTH BEACH! An exotica of beatniks, palm readers, interracial couples, and coffeehouses. Ground zero for the avant garde. Margaret

waits on a busy corner, a bit dazed, peering at the parade of fun-loving hipsters. Primly, she fixes herself.

Margaret turns—and suddenly grins. Running up is DEE-ANN, 30, a beatnik girl in a black leotard and sandals. Dee-Ann excitedly grabs her, and they laugh and hug girlishly.

> DEE-ANN
>
> Sugar, you made it! You're in North Beach!

> MARGARET
>
> Deirdre, look at you!

> DEE-ANN
> *(correcting)*
>
> "Dee-Ann."

> MARGARET
>
> "Dee-Ann"?!

> DEE-ANN
>
> Yeah, I know. But I hit this scene . . . and "Deirdre" just sounded like something my mother would call me.

Margaret giggles.

> DEE-ANN
>
> So are you flipping for all this?! Are you settled? How's Jane?

> MARGARET
>
> Jane—is swell. She's started in a sweet little school.
> *(pause)*

Though . . . it's hard without her father.
I'm not sure we can do this . . .

The thought hangs, and Margaret gets emotional. Teary-eyed.

> DEE-ANN
> Oh stop that. You're better off. Between
> us, I never liked Frank.

> MARGARET
> *(shocked)*
> You were a *bridesmaid*!

> DEE-ANN
> Exactly. That's why I couldn't speak up.
> But if I ever see you wrong off again, *I
> will tell you.*
> *(long beat)*
> Now come on. Let's have some fun.

WIDE

They start WALKING. Dee-Ann gestures.

> DEE-ANN
> Toss off your middle-class preconcep-
> tions! This is Pompeii! We're livin' in the
> volcano!! For jazz, check up the hungry i.
> For Italian, Vanessi's. For salvation, try the
> Buddhist temple. For art, the Six Gallery—

*They pass a GALLERY. The displays are stark, Calder-like MOBILES
and found-object SCULPTURES. Margaret stares, unsure.*

> MARGARET
> Do they only show modern?

> DEE-ANN
>
> *Everyone* only shows modern!

She points.

> In the basement, they've got espresso.

> MARGARET
>
> What's espresso?
> (*worried*)
> Is that like reefer?

Dee-Ann LAUGHS, astounded.

> DEE-ANN
>
> You've got a lot to learn!

EXT. ART SHOW — DAY

A Sunday ART SHOW. It's picturesque—amateur ARTISTS display-ing their paintings, jewelry, sculpture . . .

The modern stalls are crowded with trendy BOHEMIANS. Abstract lines, speckles of color. We drift away . . . and find Margaret, alone in her stall with Jane. Margaret sits patiently, surrounded by Big Eye paintings and charcoal portraits. In contrast with the neighbors, her work seems . . . quaint.

A pink, chubby TOURIST FAMILY ambles over. Margaret brightens hopefully.

> TOURIST GUY
>
> Your stuff is cute. How much?

> MARGARET
>
> Today's a special: Two dollars.

—— • ——

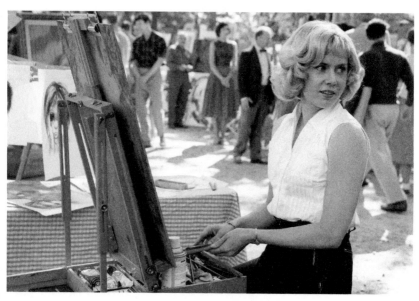

Margaret sketches children's portraits at a San Francisco art fair.

—— • ——

> TOURIST GUY
>
> I'll give you one.

Beat—then she nods, agreeing. She gestures.

The little BOY sits. Margaret clips a fresh sheet of paper, sharpens her charcoal . . . and . . . goes motionless. Studying the boy's face. He gazes back.

Then—inspired, she begins sketching his EYES. Large and exaggerated. Then she fills in the shape of his head. His ears. His jaw.

In a rush, his likeness appears. The parents come over to peek—then gasp. Margaret is good. She sketches faster. Focused. Until a LOUD, PLUMMY VOICE drifts in . . .

> MAN'S VOICE
>
> Monet? "Monet"?! Whew—that's a hell of
> a compliment. Though, if I may respect-
> fully disagree, I'm more in the tradition of
> Pissarro.

Margaret looks up, distracted. She resumes her work.

> MAN'S VOICE
>
> C'mon, get closer. Closer! Look at that
> sunlight coming through the mottled
> leaves. That's a bold yellow!

Curious, Margaret casually peers over . . .

HER POV

Holding court in another booth is WALTER KEANE, 40. Walter is astonishing: Hugely confident. Charming. Waggishly handsome. And dressed like an "Artist"—striped turtleneck, with hands full of brushes.

Walter's stall is filled with oils of Paris street scenes. He casually flirts with TWO YOUNG COEDS. They admire a painting.

> WALTER
> You wanna touch it? Do it! I lay it on
> thick—you're not gonna break it!
> *(unwavering)*
> I poured myself into that painting. It's
> thirty-five dollars.

Walter glances over—and notices Margaret watching him.

Shy, she quickly turns away, back to her portrait.

Walter smiles rakishly. He's found a new interest.

> WALTER
> Excuse me, ladies.

WIDE

Walter strides up to Margaret. She peers nervously . . . trying to ignore him. She sketches faster. Shading . . .

Walter watches. Admiring . . . and discreetly smelling her hair.

Margaret pays no attention. Done, she blows into a can of Fix-It. Poosh! A fine mist sprays, setting the portrait. Without fanfare, she humbly turns the picture.

> MARGARET
> All finished.

Her customers gape, impressed. She smiles. The guy counts out four quarters, then happily leaves.

Margaret and Walter are left together. An unspoken frisson, until—

> WALTER
>
> You're better than spare change. You shouldn't sell yourself so cheap.

> MARGARET
>
> I'm just glad they liked it.

> WALTER
>
> Ahhh! You're past that point! Your heart is in your work . . .

He leans in, too close. Margaret shivers. Breathing faster.

> WALTER
>
> What's your name?

> MARGARET
>
> M-Margaret . . .

Mmm. He grins, checking her out . . . her loose sexy blouse and tight black capris. She flushes.

> MARGARET
>
> Wouldn't you rather flirt with those dolls over there?

> WALTER
>
> Mm, no.
> > (beat)
> I like *you*, Margaret . . .

He zeroes in on the artworks' signature: "M. Ulbrich."

> WALTER
>
> ". . . Ulbrich."
> *(impassioned)*
> You know, Margaret Ulbrich, you're
> undervaluing yourself. Lemme show you
> how it's done.

Walter spins to Jane. He SHOUTS out, like a carnival barker.

> WALTER
>
> Little girl! How would you like your
> portrait sketched by the world-renowned
> *Margaret Ulbrich*?! Queen of the Bay! In
> mere minutes, she will capture your soul!

Hm. Jane shrugs, unimpressed.

> JANE
>
> Nah.

> WALTER
>
> "Nah"?!
> *(he grabs a PAINTING)*
> Don't you wish this were *you* in this beau-
> tiful painting??

> JANE
>
> But that IS me! And that's me . . .
> *(she POINTS all over)*
> And that one started as me, but then
> Mother turned it into a Chinese boy.

Huh? Walter peers at Jane . . . then at Margaret. And then—it hits him. He grimaces, embarrassed.

> WALTER
>
> Oh, you're *Mommy*! My apologies, honey. I misconstrued the situation.
> (*sheepish*)
> Well, I'll just mosey along, before Mr. Ulbrich comes back and socks me in the eye.

ON MARGARET

A gut decision. She stares at Walter, then smiles slyly.

> MARGARET
> Mr. Ulbrich is out of the picture . . . !

ON WALTER

His face slowly lights up. Ah! Sun breaking through clouds.

CUT TO:

EST. FRENCH BISTRO—NIGHT

INT. BISTRO—NIGHT

An enchanting bistro. Wine barrels, laughing, twinkly Tivoli lights. Perfection. Walter flamboyantly enters, escorting Margaret. Instantly, the STAFF ERUPTS in excitement: "Monsieur Keane! Ah, Monsieur Keane is here! Bonsoir!"

> WALTER
> Bonsoir, gang! Henri! Sorry I didn't call first. *Est-ce que tout va bien?*

> MAÎTRE D'
> *Je vais bien, merci! Comment allez-vous?*

> WALTER
> *Je vais bien!* I'm with a beautiful woman!
> Could life be any grander??

They get led in. Margaret is dazzled. Walter whispers.

> WALTER
> And I don't even have to pay! I'm set
> because I gave the chef a painting. You
> know what he said? "Nobody paints
> Montmartre like Walter Keane!"

LATER

Margaret and Walter enjoy an intimate dinner. The wine flows.

> MARGARET
> I can't believe you lived in Paris.

> WALTER
> Best time of my life . . .

> MARGARET
> I've never even been on an airplane.

> WALTER
> Well you have to *experience* these things!
> Grab 'em!!
> (*jocund*)
> I wanted to be an artist, so I just *went*!
> Studied painting at the Beaux-Arts. Lived
> in a Left Bank studio. I survived on bread
> and wine . . .

> MARGARET
> You're a romantic.

WALTER

Damn right!

A wistful shrug. He chugs his glass.

WALTER

Of course, walkin' away from the bourgeois
scene wasn't a snap. I had to quit my job.
Leave my wife. These choices aren't easy . . .

She stares at her wine.

MARGARET

I've never acted freely. I was the daughter.
The wife. The mother . . .
(she sighs)
All my paintings are of Jane, because she's
all I know.

WALTER

You shouldn't knock your work. I'd give
an eyetooth to have your talent.

Margaret is taken aback. He's absolutely sincere.

WALTER

You can look into someone and capture
them on canvas! You paint people!
(he gestures sadly)
I can only paint—things. My street scenes
are charming . . . but at the end of the
day, it's just a collection of sidewalks and
buildings.

Walter goes silent. He has revealed his fears.

ANGLE—MARGARET

She doesn't know what to say. Gently, she takes his hand.

> MARGARET
> Walter, I'd bet you could paint anything.

> WALTER
> (*intense*)
> Whew . . . Baby, when you look at me like
> that, I could fall hard.

Margaret gulps. Afraid to talk.

> MARGARET
> This is moving fast. You're my first date
> in a long time . . .

Neither of them speaks. The tension builds—

There is a spark between them . . .

CUT TO:

EXT. PALACE OF FINE ARTS—DAY

A lush green knoll, overlooking the park. Margaret and Walter have set up TWO EASELS. They both smoke cigarettes. Margaret is spattered with paint, stirring colors. Walter paces about, framing the scene with his fingers.

Jane sits in front of them, playing paddleball. Bonk! Bonk!

> MARGARET
> Sweetie, could you stop fidgeting?

JANE

Mother, after all this time, you MUST
know what my face looks like.

*Margaret winces. Walter laughs. She gets busy, penciling in LARGE
OVAL EYES. Then—quick marks for the mouth and nose. Impatient,
Jane spies on Walter's canvas.*

JANE

Hey! Your canvas is *blank*!

WALTER

Er, you can't rush inspiration—

MARGARET

Jane! Don't bother Mr. Keane. You
know creativity has to well up from the
inside . . .

WALTER

Don't worry. She's not bothering me . . . !

Walter leaves Jane. He points at Margaret's canvas.

WALTER

There's something I gotta ask you. What's
with the big crazy eyes . . . ?

MARGARET

I believe things can be seen in eyes.
They're the windows of the soul—

WALTER

Yeah, but, *c'mon*! You draw 'em like

pancakes! I mean, they're WAY out of
proportion!

He's having fun, but she remains serious.

 MARGARET
 Eyes are how I express my emotions.
 That's how I've always drawn them.
 (earnest)
 When I was little, I had surgery that left
 me deaf for a period. I couldn't hear, so I
 found myself staring . . . relying on peo-
 ple's eyes . . .

She smiles shyly. Understanding, he smiles back. Then—

 VOICE
 Walter? Hey—Walt!

Walter spins, startled. A FRIENDLY GUY in a suit strolls up.

 FRIENDLY GUY
 I thought that was you!

 WALTER
 (embarrassed)
 Oh! Uh . . . er, hi, Don.

 FRIENDLY GUY
 Boy, I'm glad to see you! Have we heard
 back from the city, on that setback? My
 guys really need the variance, for the first
 floor retail.

Walter is mortified. He turns away from Margaret.

WALTER

Um . . . we should hear from Permits by
Thursday.

FRIENDLY GUY

Yeah? Well that's terrif'! I'll tell the
architects!

Pleased, the guy cheerily strides away.

ON WALTER AND MARGARET

He is stricken. Something ominous just happened.

MARGARET

What was *that*??

WALTER
(ashamed)

I—I didn't want you to know . . .

*A long, horrible pause. Walter's face turns gray. We SLOWLY PUSH
IN. This revelation is churning. Agony.*

WALTER

I'm in commercial real estate.

A stunned beat.

MARGARET

You're a—*Realtor?*

WALTER
(contrite)

YES! A hugely successful Realtor! Top earner
in the downtown office *three years running!*

———— • ————

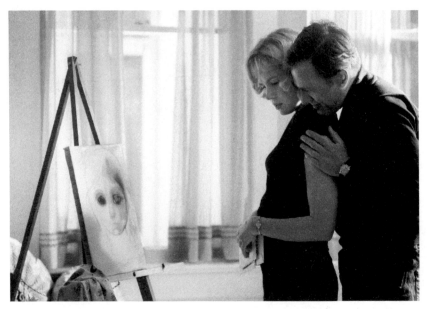

Walter and Margaret share a tender moment as they fall in love.

———— • ————

MARGARET

And you're . . . ashamed?

WALTER

Of course! Any blockhead can arrange a
sublet!

(heartfelt)

All I ever wanted was to support myself as
an artist . . .

(sad; beat)

I tried to make a clean break, but couldn't
cut it. I'm just a goddam Sunday painter.
An amateur.

Margaret looks at him, touched by his vulnerability.

CUT TO:

INT. MARGARET'S APARTMENT—DUSK

*End of the day. Golden light slants in through the windows of this small,
tidy apartment.*

*The door opens. Margaret holds it for Walter, who chivalrously staggers
in, carrying all her supplies: easel, paints, cans. He carefully puts it all
down—then turns.*

*Beat. Walter stares at Margaret, their faces caught in the warm light.
Then, enchanted, he kisses her.*

Silence.

*Margaret smiles, captivated. Caught in his glow. The moment could last
forever . . .*

IN THE DOORWAY

Jane stares unhappily. Threatened.

> JANE
>
> A-*hem*!

ON MARGARET

She turns, startled. Feeling guilty, Margaret rushes from Walter. Busying herself, she skims through the MAIL.

Jane shakes her head and marches out.

Margaret flips through envelopes—until one stops her. On edge, she slowly removes an official DOCUMENT. She scans it . . . and her face drops. Crushed. Something terrible . . .

Walter is worried.

> WALTER
>
> What's wrong . . . ?

> MARGARET
> *(soft)*
> Frank wants to take away Jane. He says
> I'm an unfit mother . . .

Walter is taken aback.

> WALTER
>
> You're a perfect mother.

> MARGARET
>
> He told the court Jane doesn't have a
> proper home. It's beyond my abilities as a
> single woman . . .

Margaret trails off, shaken.

Walter gulps unsurely. Then, he takes her in his arms. We SLOWLY PUSH IN.

WALTER

Marry me.

MARGARET
(she GASPS)

Walter! I—

WALTER
(he puts a finger to her lips)

Shh. Don't think of a reason to say no.
'Cause I've got a million reasons to say yes.
(he gives a winning smile)
I know it makes no sense! But just think of the
fun we'll have. . . ! And I'll take care of you
girls.

Margaret stammers, speechless. She doesn't know what to say.

Walter pulls out his ace. In a debonair move, he creakily drops to his knee.
He exudes a hammy, wonderful romance:

WALTER

Margaret, I'm on my knee! C'mon, whatdya
say? *Let's get married!* We can be in Hawaii
by the weekend.

MARGARET

Hawaii? M-marriage?
(emotional)
Walter, I'm crazy about you . . . but I'm
overwhelmed. Why would we go to Hawaii?!

 WALTER
 (beguiling)
 Because you're a princess . . . and you
 deserve to get married in paradise.

CLOSE-UP—MARGARET

Margaret shudders, tears in her eyes. Hawaiian MUSIC begins . . .

 DISSOLVE TO:

STOCK FOOTAGE—DAY

A propeller-driven PAN AM airplane soars through the sky.

EXT. HAWAII—DAY

Hawaii, 1958. Heaven on earth. Blossoming flowers, rare birds, lush greenery. Margaret is experiencing total bliss.

We widen. She and Walter stand in front of a waterfall, getting married. Jane is maid of honor. A PRIEST smiles, and Walter places a ring on Margaret's finger. They kiss.

EXT. BEACH—SUNSET

Margaret and Walter lie on the sand, making out. Cuddling, running their fingers along each other's bodies. She stares up, endlessly happy.

 MARGARET
 You're right . . . this is paradise. Only
 God could make those colors.

 WALTER
 I knew you'd love it.

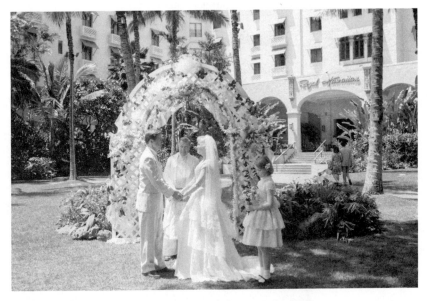

The Hawaiian wedding of Mr. and Mrs. Walter Keane.

MARGARET

Oh, can't we stay here forever??

WALTER

Well, I don't know about forever. But
maybe . . . I can arrange another week.

EXT. HOTEL GROUNDS—DAY

Thatched umbrellas, Polynesian fun. Margaret is set up, drawing POR-
TRAITS of the GUESTS. Walter regales them as they wait. Joking,
gregariously handing out mai tais.

Margaret finishes a picture. She beams at Walter . . . then signs the picture
"KEANE."

Walter gapes, astonished at this gesture. Margaret locks eyes with him.
She smiles girlishly, radiating happiness.

CUT TO:

INT. CHINESE RESTAURANT—DAY

Old school Cantonese: Dragons and red lacquer. Margaret eats lunch with
Dee-Ann, showing off SNAPSHOTS from the trip.

MARGARET

This is a waterfall . . . The air was so
fresh you could taste it. Here's an ancient
altar . . . That statue is Kane, the god of
creation. I said a prayer to him. Oh! Here's
Walter and Janie, building a sandcastle—

Dee-Ann raises an eyebrow.

DEE-ANN

This is all happening mighty quick. In
the time you moved here, I've had two
dates. You're already married.

MARGARET
(she giggles)
I thought there was a void in my life.
Well . . . Walter's filled it.

DEE-ANN

Walter's filled a lot of things. He's diddled
every skirt on the art circuit.

MARGARET
You're talking about my husband!

DEE-ANN
I know! That's why I brought it up.

Margaret frowns, insulted.

MARGARET
I'm not naive.
(beat; she laughs)
Well, I *am* naive. But I know the man I'm
marrying. Walter can act rash . . . but he's
a good provider. And he's wonderful with
Jane.
(clear-eyed)
Look—we're both looking for a fresh
start. I'm a divorcée with a child. Walter
is a blessing.

Dee-Ann bites her tongue. The WAITER brings over the check. Sitting on it are TWO FORTUNE COOKIES.

Hm. Margaret stares, utterly serious. She reaches for one . . . then impulsively grabs the other. She cracks the cookie. Dee-Ann waits, curious. Margaret reads . . . then slowly smiles.

> MARGARET
> "You are on the threshold of untold suc-
> cess."

INT. ART GALLERY—DAY

A Modish, happening gallery. The white walls are hung with ABSTRACT EXPRESSIONISM: slashing angles of color, painted-over rags and glued bolts. On the floor is SCULPTURE made from wood and wire.

In charge is RUBEN, a fussy man in a goatee. He's schmoozing a FAN-CY LADY. They look at a spattered, distorted painting.

> RUBEN
> What's brilliant about the composition is
> its spontaneity. The image has no visual
> center of attention.

> FANCY LADY
> It's quite gestural.

> RUBEN
> Oh definitely! Strongly influenced by the
> *tachistes*.

> FANCY LADY
> I heard Tab Hunter was in here, looking
> at one.

> RUBEN

Well . . . I'm not allowed to say . . .

He NODS HIS HEAD up-and-down: Yes, you're right.

OUTSIDE

A car backfires. Ruben turns—and winces.

Through the windows is Walter, climbing out of his massive white Cadillac. He's all done up, in beret and scarf. He opens the giant trunk and removes a pile of paintings.

Ruben cringes knowingly. He whispers:

> RUBEN

Oh Christ, don't come in here. Please
don't come in here . . .

The door SLAMS. Walter loudly barges in.

> WALTER

Ruben, good day! Do you got a minute?

> RUBEN

Walter. In polite society, the word is
"appointment."

> FANCY LADY
> *(glancing back and forth)*

Uh, I could come back later . . .

She anxiously hurries for the door. Ruben fumes.

Walter ignores it all and starts laying out his wares. First, the Parisian street scenes, one after another . . .

WALTER

You're gonna love my stuff today.

RUBEN

Haven't I seen that one before?

WALTER

Nah! That was painted in the Fifth
Arrondissement. This is the Sixth
Arrondissement!

RUBEN
(skeptical)
I don't understand. You lived in Paris for
a week. How can you still be cranking out
paintings?

Walter laughs. He points to his head.

WALTER

It's all up here.
(beat; a sentimental flourish)
And here.

He points to his heart. Ruben frowns and points to the wall.

RUBEN

Well, it's not going up *here*.
(cruel)
Walter, you know we don't go for that
representational jazz! You're too literal.

WALTER
(hurt)
Hey, *art isn't fashion*!

 RUBEN
Yes it IS!
 (cutting)
People want Kandinsky, or Rothko! They
don't want goopy street scenes.

CLOSE-UP—WALTER

Ouch! This stings terribly.

*Walter glares at the man, then softly slides aside his works. Quietly, he
pulls out Margaret's Big Eye paintings.*

 WALTER
Would they want . . . this?

 RUBEN
 (he shudders)
Good God! You've entered a new period.

 WALTER
No . . . they're my wife's.

*Fascinated, Ruben glances through Margaret's oils. Canvas after canvas
of sad kiddies against gray, bleak backgrounds.*

 RUBEN
Why are their eyes so big?! They're like
big stale jellybeans.

 WALTER
 (snide)
It's Expressionism. Surely you recognize it.

 RUBEN
 (*long beat*)
Well—I'm just glad you two found each
other.

 WALTER
So . . . what do you say?

Ruben looks up, amazed. Walter seems oblivious.

 RUBEN
I say, NO! It's not art.

 WALTER
 (*horrified*)
Not—"art"??

 RUBEN
It's like the back of a magazine! "Draw the
turtle! Send in a nickel and win the big
contest!"

 WALTER
How dare you! Lots of people would like
this.

 RUBEN
Well, nobody who's walking through the
door of this gallery!
 (*beat*)
Now please! Clear out this clutter, before
the taste police arrives.

Walter's jaw drops.

CUT TO:

EXT. HUNGRY I MARQUEE—NIGHT

The hungry i—the hottest nightclub around, so hip it's in a basement. The marquee says "Cal Tjader, TONIGHT!"

INT. HUNGRY I SHOWROOM—NIGHT

A swinging mob of BEAUTIFUL PEOPLE—suits, gowns and pearls. CAL TJADER'S BAND is crazed: vibes and bongo-driven JAZZ.

Margaret and Walter are squeezed in at a table. She nurses a Grasshopper. Walter's in a foul mood, CHUGGING cocktails.

> WALTER
> We'll *never* break in . . . ! Because there's a
> CABAL. A secret society of gallery owners
> and critics, who get together for Sunday
> brunch in Sausalito, deciding what's "cool."
> *(brooding)*
> They're like Freemasons. No, *worse!*
> McCarthy, in his hearings: "That painter,
> I anoint. That painter, I banish to
> nowheresville!"

Heartfelt, Margaret disagrees.

> MARGARET
> I think people buy art because it touches
> them—

> WALTER
> Heh! You're livin' in fairy land! People don't
> get to discover a thing. They buy art, because
> it's in the right place at the right time.

O.S., MUSIC BUILDS. Muddled, Walter turns. He looks—and then—his eyes light up. He is getting an idea . . .

ONSTAGE

The band speeds to a climax, the percussion throbbing. Then, a final, crazed note. BAM!!

The crowd APPLAUDS. The club's owner, ENRICO BANDUCCI, bounds on stage. Banducci is a theatrical, natty Italian guy with a skinny moustache and loud personality. He grabs a mike.

> BANDUCCI
>
> Give it up for Cal Tjader! That set was
> HUMMIN'! Al-aright, be sure to stick
> around for the one a.m. show!

The house lights come up. Banducci hops down, greeting guests, making his way out—when Walter glides up.

> WALTER
>
> Hey, Banducci. I love the music tonight.
> It's a gas.

> BANDUCCI
>
> Oh. Thanks, thanks.

> WALTER
>
> I'm Walter Keane. I'm a painter.
> *(knowing)*
> I was looking at your walls, and they're
> pretty plain.

> BANDUCCI
>
> Really? Hm . . . ! Maybe you're right.
> What color were you thinking?

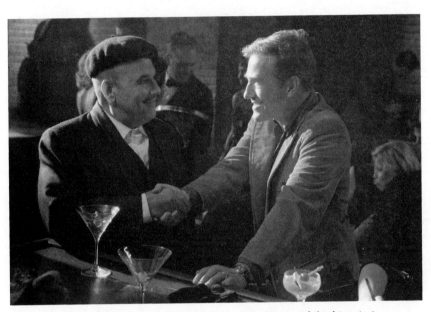

Walter Keane cuts a deal with Enrico Banducci to exhibit his paintings at the hip hungry i nightclub.

Huh? Walter holds his composure.

> WALTER
>
> No—I'm an artist. I used to be based on
> the *Left Bank*. But now I've relocated to
> the "States," and I'm looking for an . . .
> exhibition venue.

Beat. Banducci frowns.

> BANDUCCI
>
> I like my club the way it is. Your stuff's so
> hot, go put it in a museum.

> WALTER
>
> Okay! I respect that. You're a business-
> man, not a charity! So how 'bout if I,
> uh . . . *rented* your walls?

Hm?! Banducci raises an eyebrow.

CUT TO:

INT. BERKELEY APARTMENT—DAY

*Walter's swanky pad is CHAOS, filled with cameras and lights. A PHO-
TOGRAPHER runs around, tweaking equipment.*

*Walter's at an easel, putting the final touches on a PAINTING of a
French street scene. He gabs on the PHONE.*

> WALTER
>
> Yes! The paintings are available for public
> viewing daily, from seven to three!
> *(an awkward beat)*

Er, no. Three *a.m.* It's in a nightclub.
> (*he hangs up*)

Maggie! It's promotion time! We gotta
lay the racket!

Margaret puts on a smock, a bit dumbfounded. Walter spatters some paint on his shirt. He grins, then holds up his brush and SIGNS the painting: "W. KEANE."

Margaret forces a "cheese" smile, with her Waif. FLASH! The camera pops.

CUT TO:

INT. HUNGRY I—NIGHT

CU—A cheery BROCHURE, "Meet the Keanes!" There's a staged PHOTO: Walter at his street scene, Margaret at her Waif.

Then—a SHOE steps on it. We WIDEN . . . revealing the brochure on the sticky floor of . . .

THE CLUB! It throbs with frolicking CUSTOMERS. We move through the pack. To a rear concrete hallway . . . to a sign with an arrow: "TOILETS." We go down the hall . . . into . . .

A DINGY CORRIDOR

The Keane paintings hang here. The only human in sight is Walter, forlorn at a card table. Brochures are stacked, and he wears a sailor coat with a dandyish ascot.

The image is grim. Walter listens to the raucous mob. Until, THUMP!—a sloshed MAN stumbles in. Walter brightens and stands.

WALTER

Ah, beautiful! An art lover! Yes sir, how
may I help you?

MAN
(*unclear*)
I'm, uh, just looking for the john.

A terrible pause. Walter swallows his outrage . . . then points.

*The guy smiles and tosses Walter a BUCK, as a tip. Walter is stunned.
The guy toddles away.*

*Beat. The Ladies Room opens, and TWO GOSSIPY WOMEN rush out,
oblivious to Walter. He glowers. ANOTHER MAN bounds in, right up
to one of Walter's paintings! He stops at it.*

Walter gathers a moment of hope. Does he like it?

*Then the man leans down and opens a CLOSET. He removes a tray of bar
glasses, kicks the door shut, and scoots away.*

ANGLE—WALTER

*He grimaces . . . beaten. Walter drops his head on the table. Not noticing
a DRUNK COUPLE stagger in. They pass a Waif, then halt—taken.
They lean in. Enthralled . . . concerned . . .*

TIPSY LADY
Look at that child. She's so sad.

TIPSY MAN
Is she poor . . . ?

TIPSY LADY
She's *forgotten*! It just makes me want to cry.

(she peers at the signature, then turns)
Are you "Keane"?

Walter lifts his head from the table.

> WALTER

Yeah.

> TIPSY LADY

Well, you're a hell of a painter.

Walter squints, confused, then beams. Joy! Happiness bursting like a little child.

> WALTER

Why, thank you . . . ! Thank you so much!

> TIPSY LADY

Your work is very powerful. There's so much emotion in those eyes.

OUCH! Walter's smile collapses.

> TIPSY LADY

Is something wrong?

> WALTER
> *(reeling)*

Huh? Uh . . . no. No. I just didn't realize you meant . . . the waif.

> TIPSY MAN
> *(beat; he CHUCKLES)*

Oh, I get it . . . ! The artist doesn't wanna part with his *favorite piece* . . .

The man winks, then pulls out a WAD OF BILLS.

Walter stares morosely.

INT. HUNGRY I—LATER

Walter sits at the bar, toasted, drinking. In a dark place. His misery is interrupted by happy Banducci, groping two GALS.

> BANDUCCI
>
> Hello, Picasso! Nice crowd, eh?

> WALTER
>
> *(sour)*
>
> You wouldn't know it from that broom closet you parked me in.

> BANDUCCI
>
> Hey, it's prime thoroughfare! People drink, they gotta relieve themselves.

> WALTER
>
> *(muttering)*
>
> "Location, location, location . . ."

Walter wallows in self-loathing. Suddenly, he explodes.

> WALTER
>
> It's INSULTING! When people see art, they shouldn't think of SHIT!

> BANDUCCI
>
> *(shocked)*
>
> Whoah! Watch it with the purple language. We got ladies present—!

Banducci PUSHES Walter away.

In reaction, Walter sloppily SMACKS him.

Riled, Banducci suddenly takes a SWING! Walter stumbles, and Banducci's punch accidently HITS the GIRL.

Ow! She topples. Walter gasps.

He SWATS Banducci—then RUNS! Cameras FLASH. Wild whoops. Walter barrels down the hall, Banducci chasing. The brawl's gone nuts. Walter grabs a Waif and SMASHES it over Banducci's head. CRASH! Banducci drops.

CUT TO:

INSERT—*SAN FRANCISCO EXAMINER*

The front page! A small headline says "BISTRO BRAWL: BANDUCCI AND ARTIST SLUGFEST." Below are two PHOTOS: Walter mid-punch, and Banducci unconscious, sticking out of the Big Eye.

EXT. POLICE STATION—DAWN

A neighborhood precinct, quiet at 6 a.m. Doors open, and Margaret leads Walter out. She's seething. He's bruised, with a mortified drunk-tank, slept-in-my-clothes swagger.

> MARGARET
> I've never posted bail before.

Silence. He has no idea what to say. His aplomb crumbles.

> WALTER
> I'm—I'm sorry. Banducci . . . laughed at
> our work. . . . So I socked him.

MARGARET

Since when are you thin-skinned? Artists
have to handle criticism.

WALTER

You're right! I know. But . . . I was
already in a bad place. I'd had a couple . . .
and earlier . . .
 (pause)
I let some guy think I painted your Big Eye.

Beat. Margaret is stupefied.

MARGARET

I don't understand. Why would you do
such a thing?!

WALTER

It was a misunderstanding. And then, I
didn't want to jinx the sale.

He shrugs feebly. She frowns.

MARGARET

Don't ever do it again.

INT. HUNGRY I—NIGHT

The club is a ZOO. PARTIERS swarm the door, trying to enter.

Suddenly, Walter pushes his way down the outside stairs. The DOOR-
MAN starts to protest, but Walter somberly waves him off.

WALTER

Don't give me a hard time. I'm just grab-
bing my stuff . . .

Across the packed room, he spots Banducci with a black eye. Walter halts, uncertain. A bristling tension . . .

Until—Banducci suddenly rushes and GRABS him! Walter flails, freaked. Banducci DRAGS him into a back kitchen—

INT. CLUB KITCHEN

Banducci shuts the door, looks around . . . then suddenly LAUGHS! He grins manically and pulls Walter into a hearty HUG.

> BANDUCCI
> Can you believe this? We're sold out, and
> I *don't even have a headliner*!!
> > (gleeful)
> Hell, it's a *Monday*!

Walter blinks, lost. Banducci explains.

> BANDUCCI
> Dope, we made *the front page*!! People
> are here, 'cause they wanna see the sappy
> paintings that made grown men fight!!

A moment of discombobulation . . . until—Walter slowly grins.

INT. CLUB—SECONDS LATER

The two men suddenly tumble into view, SCREAMING.

> WALTER
> I'll see you in COURT, you son of a bitch!
> I'm suing you for assault! Slander! False
> arrest!!

Banducci storms away.

Walter shudders, "upset." CUSTOMERS peer at him . . . then at the paintings. Curious, they migrate that way . . .

Walter glances sideways. Gauging their reactions . . .

Until—a swinging middle-aged guy in horn rims and a suit lopes up. DICK NOLAN: A man who hides his bored emptiness under a veneer of booze and broads. Dick leans in.

> DICK
>
> Yes sir! Whew. That was quite a load of
> horseshit you gents were layin' out there.
> *(long beat)*
> Dick Nolan. The *Examiner.*

Walter freezes up. Until—Dick grins conspiratorially.

> DICK
>
> Hey pal, don't lose any sleep. I eat this
> stuff with a spoon! It gives me something
> to type about, in my column.

> WALTER
> *(he laughs, relieved)*
> I thought you only did celebrities.

> DICK
>
> Well, Banducci's famous—and you hit
> him! So you're a celebrity, once-removed.
> *(he chuckles)*
> *Buy me a drink?*

> WALTER
> Huh? Uh, sure—

Dick smoothly drags him to the bar. Dick waves the bartender.

DICK

Gary! I'll have a Ward Eight, in a frosted
high boy. My friend'll have the same.
 (he beams, then turns)
So! Walter, tell me about your work—

WALTER

Well, when I was in Paris . . .

DICK

Jesus, not those! I mean the little hobo kids.

*What?! Walter frowns, peeved. He considers this indignity . . . then de-
cides to stomach it. He smiles fakely, effusively.*

WALTER

What do you wanna know . . . ?!

CUT TO:

INT. BERKELEY APARTMENT—LATE NIGHT

*Margaret is asleep. Suddenly Walter bursts in, drunk and jocular. He
FLIPS on the lights.*

WALTER

Ding-a-ling! Wake up, we're a HIT!

*Margaret rolls over, groggy. Walter jumps on the bed, grinning. He tosses
her a HANDFUL OF MONEY.*

WALTER

What a night! I sold out all your Big Eyes!!

She rubs her eyes, amazed.

> MARGARET
> There must be two hundred dollars . . .

> WALTER
> They adore you! 'Cause of that article, the
> joint was PACKED. And then, a famous
> journalist showed up, and—I need more
> paintings! *Now!*

He hungrily KISSES her. She laughs.

> MARGARET
> Walter, they take at least a week. There's
> layering, shading—

> WALTER
> Of course! But, this is *opportunity*! Ah,
> we're gonna make a crackerjack team:
> Me schmoozing up the club, while you're
> back here, doing what you love!

She stares at him—then smiles. MUSIC . . .

CUT TO:

INT. APARTMENT—NIGHT

Margaret happily paints away. At peace, lost in her art . . .

INT. HUNGRY I—NIGHT

Walter sells Big Eyes. Shoving cash into a cigar box.

INT. APARTMENT—DAY

*Margaret works, HUMMING serenely. On the easel is a half-finished
blonde girl in a blue dress.*

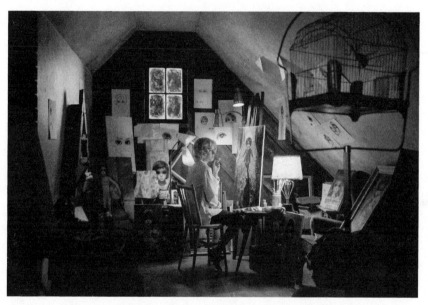

Margaret finishes one of her signature big-eyed paintings, alone in her studio.

INT. TAILOR'S—DAY

Walter buys a new suit. A TAILOR measures him.

INT. APARTMENT—LATE NIGHT

Margaret finishes painting a sad boy, using a fine brush to add a watery rim to his eyes. Magically, this detail brings the picture to life. She's pleased.

Margaret signs "KEANE." There are two finished canvases, the sad little girl and boy. Margaret smiles, her heart swelling. She loves them. Then, she looks about. Nobody is there to share the moment.

Hm. She thinks—then picks up the PHONE. She dials.

> MARGARET
> Mrs. Cava, I'm sorry to bother you so
> late . . . but would you mind watching
> Jane?

INT. TAXI—NIGHT

Margaret rides in the backseat, smiling, her gaze faraway. She proudly hugs the bundled paintings to her chest.

INT. HUNGRY I—NIGHT

The club is pounding. Margaret enters the throng, carrying her work. She looks up—and has her breath taken away. The ENTIRE CLUB, EVERY WALL, IS NOW HUNG WITH KEANE PAINTINGS!

Whoa . . . ! Pure joy envelops her.

Then—she gets jostled. Margaret notices Walter holding court with some GROUPIES. She approaches, unnoticed:

———— • ————

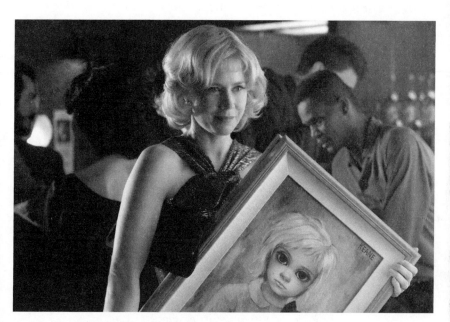

Margaret brings her latest art to the hungry i.

———— • ————

> WALTER
>
> . . . Yeah, eyes are powerful. A poet said
> they're the windows of the soul.

Margaret smiles, touched. She comes closer. . . .

> GROUPIE
> They hold so much feeling.

> WALTER
> You got it! That's why I paint 'em so big.
> *(beat)*
> I've always done it that way.

CLOSE-UP—MARGARET

She GASPS, stunned. The room starts spinning.

HER POV

> WALTER
> If you like this style, I'm working on a few
> new pieces. I've got a little blonde girl in
> a blue dress that'll tear your heart out.

ANGLE—MARGARET

Her face goes ashen. Dizzy, she clutches for support.

*What to do?? Overcome, she shrinks away . . . disappearing . . . ending
up alone in a corner. She cowers, childlike.*

ACROSS THE ROOM

*Walter LAUGHS at a joke, then backslaps the group. He jovially strides
away . . . passing by Margaret . . . when—*

MARGARET

Walter . . . ?

He spins—shocked at her presence.

WALTER

Baby!
 (discombobulated)
Hey, uh, what are you doing here? I um—

MARGARET

Why are you lying?

For once, Walter has no answer.

She bores in, emotions racing. Confused. Hurt.

MARGARET

You're taking credit for something that
isn't yours.

He looks ill. Wheels spinning, looking for an out—

WALTER

I was . . . trying to close the deal—

MARGARET

Those children are part of my being!

WALTER

I'm just a salesman! You know, buyers pay
more if they meet the painter—

MARGARET

They couldn't meet me, because you told
me to stay home!!

———•———

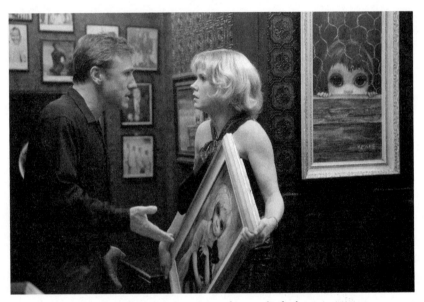

Margaret confronts Walter about taking credit for her paintings.

———•———

WALTER

Shh, QUIET!

He grabs her, pulling her behind a curtain. He's desperate.

WALTER

Don't blow this! Look, we're makin'
money! Your pocket, my pocket? What's
the difference?!

MARGARET
(trembling)
You take this so lightly—

WALTER

Not all all! But *it's not about ego*! You
wanna say you did the street scenes? Fine!
I don't care! Say a monkey painted it!

She breaks into tears, sobbing.

MARGARET

I'm glad you can dash off your pieces
without any emotional connection . . . !

WALTER

Ah, honey! I just wanna share them with
the world!
(beat)
Would you rather have your children piled
in a closet . . . or hanging in someone's
living room?

Silence.

Then—FLASH! FLASH! FLASH!

Walter turns. And—his eyes pop, astonished.

AT THE DOOR

Is an incredible sight. Like a moment from La Dolce Vita, a fabulously dressed ITALIAN MAN with THREE BLONDES floats down the stairs, into the club. Cameras FLASH.

Walter gapes, transfixed. He grabs Banducci.

> WALTER
> Hey. Who is that remarkably handsome
> and confident man?

> BANDUCCI
> That's Dino Olivetti—as in Olivetti
> typewriters.
> *(he smirks)*
> Don't even try, Walter. He doesn't speak a
> lick of English.

Walter stares hungrily.

ANGLE—OLIVETTI

Olivetti glides into the club—a vision of perfection with his slick hair and sunglasses. He approaches closer, closer . . . when he gets distracted. By one of Margaret's Big Eye PAINTINGS.

Walter gasps. He nudges Margaret.

Olivetti peers at the artwork. Intrigued. Then—excited. He starts gesturing and yapping in ITALIAN. The Blondes shout back. Everyone is getting worked-up.

The big-bosomed Blonde turns to Walter.

> EUROPEAN BLONDE
> Mr. Olivetti is enchanted with the paint-
> ing. He would like to know . . . who is
> the artist?

ANGLE—MARGARET AND WALTER

The moment of truth. Margaret opens her mouth . . . and no sound comes out. She clenches up. Stomach tight. Mute.

Walter gives her a second—ticktock, ticktock. Then—he leaps into Opportunity. He SMACKS his hands.

> WALTER
> *I* am!

Walter swoops over and grabs Olivetti in a hearty clasp.

> WALTER
> It's a delight to meet you, Signore! *Buon giorno!* Have you been an art lover for long . . . ?

We move in tight on MARGARET, as the SOUND DIALS DOWN.

> WALTER'S VOICE
> I call that piece "The Waif." Isn't it strik-
> ing? With its juxtaposition of girl, cat,
> and stairs . . . and its almost Flemish use
> of underpigment . . .

The SOUND dims . . . then goes SILENT.

Margaret stares in shock, unmoving.

Time seems to stop. She is frozen in grief. Until—

> WALTER'S VOICE
> Baby! *Baby!* Can you believe it?!!

CUT TO:

MINUTES LATER

Time has passed. Walter happily clutches Margaret.

> WALTER
> We made *five grand*!! Five THOUSAND
> dollars . . . !!!
> > (*giddy*)
> And that wasn't even one of your *good*
> ones!

Margaret blinks, lost.

In the b.g., Olivetti holds the painting, now wrapped-up in newspaper and twine. A pleased customer.

Margaret's face darkens.

> MARGARET
> Don't you mean . . . one of *your* good ones?

> WALTER
> No. No no! One of—OUR good ones.
> (*the spirit of generosity, he hands her a CHECK*)
> Look at those zeroes! We've hit the big
> time! We are now hanging in the collec-
> tion of Italian industrialist Dino Olivetti!
> With his patronage comes credibility!
> And with credibility comes RESPECT!

Margaret stares at the check in her hands. At all the zeroes.

> MARGARET
> What about . . . honesty?

> WALTER
> Aw c'mon! The paintings say "Keane"!
> I'm Keane, you're Keane. From now on,
> we are one and the same.

Walter pulls her tight. She doesn't resist.

CUT TO:

SERIES OF SHOTS:

INT. APARTMENT—DAY

Upbeat MUSIC. Walter frantically tosses all the BROCHURES of him and Margaret into a FIREPLACE. They burn to ash.

INSERT—NEWSPAPER

We ZOOM into Dick Nolan's SOCIETY COLUMN. Under a caricature of Dick is a highlighted ITEM. We hear TYPING:

> DICK'S HUSHED VOICE
> *"What exactly is local painter Walter Keane*
> *up to? My spies tell me a big announcement is*
> *forthcoming . . . !"*

EXT. CITY HALL—DAY

Walter proudly hands a painting to the confused-looking MAYOR.

> WALTER
>
> On behalf of the children of the world, we present this painting to Mayor Christopher!

EXT. PUBLIC BUILDING—DAY

Walter thrusts a painted Ballerina at a SOVIET DIPLOMAT.

> WALTER
>
> In the interest of peace through culture, we donate this painting to the people of Russia!

INT. PHONE BOOTH—NIGHT

Dick whispers into a phone.

> DICK
>
> The Purple Onion. Nine thirty. Joan Crawford has a dinner reservation.

INT. PURPLE ONION—NIGHT

JOAN CRAWFORD is eating with friends. Suddenly Walter lunges into view, startling her. He lugs a painting.

> WALTER
>
> Miss Crawford! In recognition of your cinematic craft, we bestow this painting, "The Lion and the Child"!

INT. APARTMENT—DAY

Margaret paints. Walter beams.

> WALTER
>
> Joan said "Marvelous"! MARVELOUS! *That's* worth more than a thousand critics!

(he CLAPS his hands)
Hey, maybe she'll come to our opening.

MARGARET
But . . . isn't it strange? Artists get *shown*.
They don't build their own galleries.

WALTER
Says who?! Like John Q. Public cares?
He's FED UP with abstract neoformalism!

She responds—but he sexily puts his finger to her mouth.

WALTER
He digs real art. *Your* art! It's beautiful.
You're beautiful . . .

Walter starts rubbing against her, dancing sensually. She laughs, embarrassed, her wet paint brushes smearing his chest.

She relents and relaxes. They dance around . . .

CUT TO:

EXT. CITY STREETS—EARLY MORNING

In the shadows, POSTERS of "The Waif" get glued up. Under her woeful face, it says "KEANE GALLERY 494 Broadway." We WIDEN, as Walter, Margaret and Jane hastily slap up the posters. They carry glue buckets and a ladder.

WALTER
Ruben's gonna choke when he sees this!

Little Jane tiredly glues another poster. She yawns.

———•———

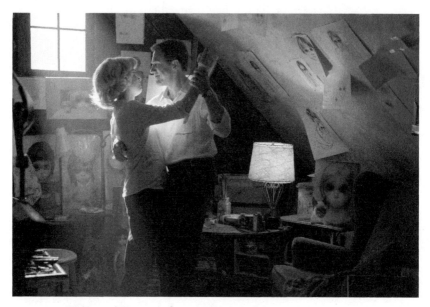

Walter and Margaret dance as their art empire grows.

———•———

> JANE

I remember when Momma painted that.

Huh?

Suddenly, Margaret freezes. She hadn't anticipated this.

Margaret looks to Walter. He stares back, waiting.

> MARGARET

Are you—sure? That was a long time ago.

> JANE

Sure I'm sure! It was in our old apartment,
and you had me sit on a stool in the kitchen—

> WALTER
> *(cutting in)*

No, dear, I'm afraid you're confused. *I*
painted that one—

> JANE

No, *Mother* did! Look! I'm wearing my
blue dress.

> MARGARET

L-lots of girls have that dress . . .

Margaret trails off, sickened. Not knowing how to lie.

Walter takes charge. He kneels, then smiles gently at Jane.

> WALTER

You have a good eye, sweetie. I painted it, but
I was trying to mimic your mother's style.
You know, the style she USED to paint in.

CLOSE-UP—JANE

A loooooong pause. She examines the print. Then . . . she nods.

> JANE
> Well you did a really good job.

CUT TO:

EXT. SAN FRANCISCO NORTH BEACH—DAY

CU on the Waif. We widen, revealing the ENTIRE WORLD has been hijacked, blanketed by THE POSTERS. People gape—astonished and captivated.

Disconnected from it all, strolling alone, is Margaret. She is burdened by her own thoughts. Regretful . . .

Across the street, she sees a GOTHIC CHURCH. She stares up, awed by the beauty. It's Catholic imagery in all its glory: Saints . . . Jesus . . . Mary . . .

Suddenly—the bells RING. Hm. Margaret takes a step . . .

INT. CHURCH CONFESSION BOOTH—DAY

Margaret tentatively enters and kneels. Beat—then the grille OPENS. She reacts, discomposed.

> MARGARET
> Hello. I've—never really done this before.
> I'm not sure how you . . .
> *(worried)*
> I was raised Methodist. If it's a problem, I
> can go—

She starts to stand. The Priest blurts out.

PRIEST'S VOICE
No, no! Please. We don't chase people
away.
 (beat)
What is troubling you?

Margaret takes a breath.

Then—

MARGARET
I lied to my child.

Pause.

PRIEST'S VOICE
Why would you do that?

MARGARET
My husband . . . he pressured me into
doing it.
 (pause)
I've never lied to her before. I'm not that
kind of person.

Beat.

PRIEST'S VOICE
Is your husband that kind of person?

MARGARET
Ummm, no. I don't think of him that
way. I mean, he likes to tell stories . . .
maybe he exaggerates a little . . . but he's
a good man.
 (she thinks)

He takes care of us. He wants to make
enough money to buy our family a
house . . .

PRIEST'S VOICE
But what of the child? Will this lie bring
harm to her?

MARGARET
"Harm"?? Oh! Not at all.
(*beat*)
I'm just looking for answers . . .

The Priest considers this.

PRIEST'S VOICE
Well, the modern world is a complicated
place. Occasionally, children need to be
sheltered from certain truths.

MARGARET
N-no. That's not what—

PRIEST'S VOICE
It sounds like your husband is trying to
make the best of an imperfect situation.
(*beat*)
You were raised Christian, so you know
what we are taught: The man is head of
the household.
(*beat*)
Perhaps you should trust his judgment.

CUT TO:

INT. KEANE GALLERY—NIGHT

Opening night! The gallery is packed with the IN CROWD: rich and drinking. The space is cool—the walls bright white, the art hanging under spotlights. JAZZ plays on the stereo.

At one painting, a HIPSTER COUPLE stares at the image of a sorrowful girl holding an armful of poodle puppies.

> HIPSTER LADY
> I think it's creepy, maudlin and amateurish.

> HIPSTER MAN
> Exactly. I love it.

We move in tight on the painting. Underneath is a tag: "BEDTIME, by WALTER KEANE. Oil on canvas."

We drift along, to another painting: "CALICO CAT, by WALTER KEANE." Then, another: "IN THE GARDEN, by WALTER KEANE."

Every painting is now by Walter Keane.

We move along . . . finding the Tipsy Man chatting up Dick.

> TIPSY MAN
> We got in early. We own three.
> *(he turns)*
> Thanks, doll.

He tosses his empty to a PASSING LADY. We reveal the waitress is . . . Margaret. She carries a tray of pigs-in-a-blanket. Margaret looks shellshocked—faking a happy party face.

A burst of LAUGHTER. Margaret turns.

Walter and a group ROAR at a joke. A SEXY GIRL hands Walter one of the promo posters. He beams and lays it across her back . . . hugging her waist to "steady" himself as he signs.

BACK ON MARGARET

She frowns. Dee-Ann slides into view, slurping champagne.

> DEE-ANN
>
> Hey, baby! Killer party! It's a hap-pen-ing . . . ! So, where's your stuff?

> MARGARET
> *(nervous)*
>
> Oh. Um, we decided that this would be Walter's show—

> DEE-ANN
> *(suspicious)*
>
> Oh "we" did?? And why would "we" do that??

> MARGARET
>
> Well . . . he's more established.

> DEE-ANN
>
> Please! Is that you talking, or did you just turn into a little felt puppet with some-one's hand up your ass?

Margaret is befuddled.

Dee-Ann scopes out the artwork.

> DEE-ANN
>
> It's strange . . . Walter doesn't strike me
> as the cute hungry kitten type . . .

Margaret grimaces.

> MARGARET
>
> Thanks for coming.

Margaret grabs a drink and hurries away.

Dee-Ann stands there, irked.

*Margaret cuts over to Walter. We MOVE IN TIGHT ON THE COU-
PLE. He grins and grabs her.*

> WALTER
>
> Ah, my sweet! Are you enjoying the scene?
> *(he gives her a kiss)*
> EVERYONE! Give a hand to my beau-
> tiful wife. Without her, none of tonight
> would be possible!

The crowd APPLAUDS politely, condescendingly.

Margaret smiles strangely. The Tipsy Man leans in.

> TIPSY MAN
>
> Your husband's quite a talent.
> *(pleasant)*
> Do you paint, too?

Margaret freezes up, terribly awkward.

> MARGARET
>
> I don't . . . know.

AT WALTER

A NOSY GUY corners him in front of a painted child.

> NOSY GUY
> I'm curious about your technique. How
> long did that piece take to execute?

> WALTER
> That? Oh, wow. Probably . . . months.
> First the thinking, the sketching, and
> then time with just me and the oils.

> NOSY GUY
> "Oils"? But isn't that acrylic . . . ?

Huh? Walter glances at the painting, startled.

> WALTER
> Oh—! You mean *that* painting! Uhh,
> sorry! It's like a jumble of ideas, rattling
> around in my brain!

Beat.

> NOSY GUY
> So where do you get your ideas?

> WALTER
> What do you mean?

> NOSY GUY
> I mean—
> *(confused at this confusion)*
> Why are they . . . images of children?

Yikes. Walter starts to sweat. He didn't think this through.

> WALTER
> Well, er, I've just always loved kids.
> Though mostly I was influenced by my
> darling daughter . . .

An odd beat.

> I remember when she was a baby . . .

Walter gets a far-off look.

> Yeah. Cute little thing. I'd stare into
> those big orbs. Sometimes I'd get out my
> Brownie and snap a photo . . . but . . .
> that's not subjective. You know? It doesn't
> capture your *feelings*. So that's when I
> started painting her . . .

We hold on Walter, unsure where reality begins and ends . . .

CUT TO:

INT. BERKELEY APARTMENT—DAY

*CU on a fuzzy TV SCREEN: A PRIGGISH MAN is griping. The
screen is captioned "JOHN CANADAY, NY TIMES ART CRITIC"*

> CANADAY (ON TV)
> Keane's work is completely without dis-
> tinction. He is not a member of the Society
> of Western Artists. He has won no awards.
> He's only noteworthy for his appearances in
> a certain newspaper's gossip column!
> *(exasperated)*

Mr. Keane is why society NEEDS critics!
To protect them from such atrocities!

Walter gapes at the TV, outraged. He suddenly grabs a PHONE.

IN THE LIVING ROOM

Jane is BANGING on a closed door.

> JANE
>
> Mom! I wanna come in.

> MARGARET (O.S.)
>
> Uhh, you can't. Mommy's busy.

> JANE
> *(she BANGS again)*
> Let me in! What are you doing in there?
> Why's the door always locked?

Walter enters—and reacts. He glides over to the girl.

> WALTER
>
> Janie, sweetie, you need to respect your
> mother's privacy. Sometimes grownups
> need alone time.
> *(he winks)*
> Is that the ice cream truck? Why don't
> you go get yourself a Fudgesicle?

Walter tosses her a dime. She peers warily, then leaves.

*He waits a beat—then pulls out a KEY. Walter discreetly unlocks the
painting room.*

INT. APARTMENT PAINTING ROOM—SAME TIME

It's a factory. Big Eyes are everywhere. Margaret frenziedly works, surrounded by half-done canvases, solvents, easels. She's in a bathrobe—a cigarette hanging from her lips.

Startled, she looks up to see Walter.

He gazes at all the art. At the bulbous faces, eyes watery and submissive, trapped in muddy yellows and dire browns. And then . . . Walter grins broadly.

> WALTER
> Whew! Out of this world . . . !

> MARGARET
> *(bothered)*
> I dunno. I'm not really comfortable with
> this. Jane and I used to be so close . . .
> but—now . . .

> WALTER
> Ah, Jane's grand! She's eating ice cream!
> She has new shoes. She has a *college fund*.

Beat.

> MARGARET
> Maybe I'm lightheaded from the turpen-
> tine. I've been in here all day.

> WALTER
> Well I don't want you feeling like a pris-
> oner. Take a break!

Walter glances at one PAINTING—then does a double take.

ANGLE—PAINTING

It's a child in a rusty alley, staring, aching for compassion. And, starting to cry. A single tear streams down her cheek.

> WALTER
> Is that a tear . . . ? You've gone deep!

Margaret bites her fingers, worried.

> MARGARET
> Do you—like it?

> WALTER
> I *love* it! . . . How'd you get the eyes so
> lifelike? Is it the highlights?

> MARGARET
> (*proud*)
> No. The secret is the *shadow*. I shadowed
> the eyelid.

Margaret smiles shyly. Walter smiles back, full of warmth. He takes her face in his hands.

> WALTER
> I owe you an apology. I was initially
> dismissive of your kids, those emotion-
> wrenching blobs of humanity . . . but they
> have a real strength.

> MARGARET
> (*she laughs*)
> Is that your best version of sincerity?

WALTER

I'm trying! Ah, you know me. See—this
is why I need your help! I want to go on
TV, to defend our art.

MARGARET

You're going to be on *television*?!

WALTER

Yes! But . . . what will I *say*??
 (beat)
Meaning—what compels me . . . to
paint . . . these paintings??

*A bizarre pause. The two of them look around the room. At all the Big
Eyes peering down at them.*

MARGARET

Maybe you have an unhealthy obsession
with little girls.

WALTER

Cute.

MARGARET
(she snickers)
I guess you've painted yourself into a
corner.

WALTER

Funny! Keep 'em coming! You're a
regular Steve Allen. You want heat this
winter? Help me out!

MARGARET

Walter . . . art is personal.

Walter picks up a picture of TWO LITTLE GIRLS IN TUTUS. He stares, perplexed.

> WALTER
> *What would make a grown man paint a picture like this?!*

No answer. He thinks of stories, wheels spinning.

> WALTER
> I grew up, surrounded by six sisters.
> *(no good)*
> I grew up in an orphanage?
> *(struggling)*
> I grew up . . . in a world where adults had vanished, and children and kittens ran wild over the desolate landscape!

Margaret smiles.

> MARGARET
> What about your Paris street scenes? Why do you paint those?

> WALTER
> Well, because . . . I lived it! I experienced it!

> MARGARET
> *(calling his bluff)*
> And was it really all sun-dappled streets and flower vendors?

Huh? Walter stares off at the Waifs. They peer out from broken windows . . . chain-link fences . . .

And then—he gets it.

WALTER

Well—NO! Of course not. It was after
the war. There was destruction every-
where . . .

(pause)

I traveled the Continent. The ravages were
horrifying . . .

CUT TO:

INSERT—FULL-FRAME TV SCREEN

*Walter is on TV, on a LOCAL PUBLIC AFFAIRS SHOW. He's coated
with makeup, sitting rigidly, fingers gripping his chair.*

WALTER (ON TV)

My psyche was scarred in my art student
days. Nothing in my life has ever made
such an impact as the sight of the chil-
dren: war-wracked innocents, without
homes, without parents, fighting over
garbage . . .

He sits in a half-circle of PROPER WOMEN, who are spellbound.

WALTER (ON TV)

Goaded by a frantic despair, I sketched
these dirty, ragged little victims . . . with
their bruised minds and bodies, their mat-
ted hair and runny noses. There my life as
a painter began in earnest.

Walter sadly looks up to the HOST.

The man is shell-shocked. Mute. Walter waits, then sighs.

> WALTER (ON TV)
> The insane, inhuman cruelty inflicted upon
> these children cut deeply into my being.
> From that moment on, I painted the lost
> children with the eyes. Those eyes that
> forever retained their haunting quality.

The ladies are stricken. A few dab their eyes.

CUT TO:

EXT. SAN FRANCISCO—DAY

Keane posters get RIPPED off a wall.

RIPPED off a mailbox. PULLED off a construction site!

EXT. KEANE GALLERY—NEXT DAY

Walter strides along, a bounce to his step. He reaches the gallery—then stops, dumbfounded. It's PACKED with PEOPLE! Not rich, but regular folks, gawking at the art.

Wow. A sweet moment . . . then some TOURISTS see Walter and happily accost him: "Walter Keane!" "Mr. Keane!" They thrust papers and POSTERS at him to autograph.

Walter grins and scribbles his signature. Glancing over their shoulders, he sees Ruben down the block, standing outside his own gallery. Gaping in disbelief.

Walter chuckles . . . then flips him off. Ruben's face falls.

INT. KEANE GALLERY—SAME TIME

Walter pushes through, shaking hands, greeting the CUSTOMERS:

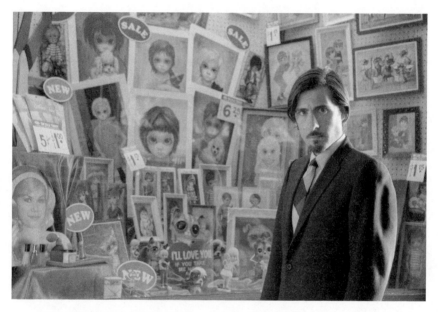

Modern-art dealer Ruben fumes over the phenomenal success of the Keanes.

> WALTER
>
> Good afternoon! Delighted!
> *(he reaches the SEXY BLONDE CLERK and pinches her ass)*
> *How many sales today?*

> BLONDE CLERK
> "Sales?" None with this crowd.

Walter's smile drops, surprised.

> BLONDE CLERK
> These people are looky-loos! They can't
> afford the paintings. But we gave away a
> heap of posters!

Huh? Walter peers, baffled. Suddenly—a loud FRWWIPPPP!

Walter whirls, startled. Outside, two GIRLS tear a big poster off the front window.

Walter's eyes widen. Slowly, he turns back. At the counter, FOLKS and KIDS are grabbing free posters from a box.

Walter stares. Processing this. And then . . . being struck by an idea of absolute genius . . .

INT. STORAGE ROOM—SECONDS LATER

Walter is on the telephone, peering through the doorway. Hiding from the customers. Spying. WHISPERING.

> WALTER (on the phone)
> It's the craziest thing. I started *charging for*
> *the posters*! First a nickel . . . then a dime.
> *(struggling to whisper)*
> YES, Maggie! It's cuckoo! So it got me

thinkin': Would you rather sell a $500
painting, or a *million* cheaply reproduced
posters?!
> (*he LAUGHS, exultant*)
See, folks don't care if it's a copy. They
just want art that touches them!

> CUT TO:

ANIMATION

> WALTER'S VOICE
> And then . . . we could sell it anywhere!!
> EVERYWHERE!

60s-style MADISON AVENUE GRAPHICS: A still of a HARD-
WARE STORE. Mops, light bulbs, then—BING!—framed KEANES.

A PHARMACY. Aspirin, candy bars—BING!—framed KEANES.

A GAS STATION. Tires, motor oil, and—BING!—KEANES.

INT. SUPERMARKET—DAY

An aisle of sundries: plastic toys, beach balls . . . Waifs. A sign says "WE
HAVE KEANE!"

Around the corner, Margaret shuffles along, listlessly buying banalities: Ce-
real. Soap. She turns the cart . . . and runs into her wall of teary-eyed kids.

Margaret peers, muddled.

Then she turns away—to a RACK OF PAPERBACKS. They offer fast
hope, inspiration. Margaret seems disconnected. She runs her hand down
the options . . . a book of Numerology . . . a book on Judaism . . . an Ed-
gar Cayce prophecies manual . . .

AT THE REGISTER—Margaret gazes up. The CASHIER is a sad Beatnik Girl. In a haze, Margaret notices the whole market is full of LONELY WOMEN:

One LADY is her doppelganger—same age, blonde, gripping a cart. Next aisle over, a MIDDLE-AGED WOMAN stares into space. Nearby, a YOUNG MOM wrangles her children.

We shift to Margaret. Face gaunt. Eyes empty. Troubled . . .

INT. APARTMENT PAINTING ROOM—DAY

Curtains drawn, Margaret frantically SKETCHES. She's cabin fever-ish. In her robe. Hair dirty. And—up to something. These sketches aren't squat children with round eyes. They're different: figures with long lines.

Margaret frowns and rips the paper. She tries again! Another angular figure—straight fingers . . . no!

Again! A woman . . . reclining. Then an indication of a face: A slash . . . and then—two small almond shapes for eyes.

Hmm. Margaret's face brightens. She likes it.

LATER

Margaret rabidly paints. Spurting globs of color. The woman is blonde, almond eyes cool, lips curled with mystery . . .

Margaret glances in a mirror. It's a self-portrait. It's Margaret, aloof. Alone at a table.

Suddenly the door opens. Margaret GASPS, startled, and spins the canvas away. Walter barges in, dressed like a million. He HALTS—making a sour face.

 WALTER

Whew! Something smells in here. You
should open a window.

Margaret blinks, a bit dazed.

 MARGARET

What time is it?

 WALTER

I dunno. Six thirty, seven? . . . Didn't
Janie get dinner?

Margaret shrugs. Walter leans in.

 WALTER

When's the last time you washed your hair?

 MARGARET

I've been . . . busy.

 WALTER
 (he notices the turned canvas; he's intrigued)
What do you got back there? Lemme see.

 MARGARET

No—! It's just . . . something I'm work-
ing on. It's not for the world.

Walter gives her a funny look.

 WALTER

"The world"? Baby, it's me!
 (stepping forward, a bit malevolent)
I'm your number one fan.

> MARGARET
> No, please! Walter, it's—personal.

> WALTER
> (getting closer)
> But we're husband and wife. We shouldn't
> have secrets . . .

Margaret gulps, fretting. Finally, without options—she flips over the canvas of the lonely blonde.

And—Walter is taken aback. His eyebrows raise, shocked.

Margaret bites her lip. Will he go ballistic?

ANGLE—WALTER

He leans right up to the painting.

His expression is inscrutable. Studying the technique. We have no idea what his emotion is.

> WALTER
> It's a completely different style.

> MARGARET
> Yes it is.

> WALTER
> (beat)
> It looks like you.

> MARGARET
> It's a self-portrait.
> Beat.

WALTER
How am I gonna explain that?

She shifts about.

MARGARET
I thought . . . maybe . . . I could sign it
myself.

Hmm. Walter's eyes narrow.

WALTER
That seems a bit confusing. "Keane"
means *me*.

MARGARET
Yes, I know . . . but . . . when people
ask me if I paint, I don't know what to
answer! I just want the pride of being able
to say—*that's mine.*

Walter's wheels are ratcheting.

WALTER
Who'd you tell about the Big Eyes?

MARGARET
Nobody!

WALTER
(*paranoid*)
Was Dee-Ann here?! Did Dee-Ann see
this painting?!

MARGARET
No! NOBODY saw it!

WALTER

You tell anybody, the empire COL-
LAPSES! Do you wanna give back the
money? We've committed FRAUD!

MARGARET

I KNOW! My God! I live with this every
minute of my life!
(*impassioned*)
Janie used to have a mother who painted.
Now what's she think?! I lock myself in
this room ten hours a day . . . and then *you*
walk out with finished paintings!

He scowls, offended.

WALTER

Janie thinks I'm in here, painting.

MARGARET

C'mon! You haven't picked up a brush in
months!
(*starting to sob*)
We used to paint together! Easels next to
each other, side-by-side—

WALTER

That was the honeymoon period!

Margaret breaks into tears. Walter tenses.

WALTER

Jesus, you're so fragile.

MARGARET

I've kept my end of the bargain! I've never
told!
(she SOBS harder)
Please! *Just let me have this*!

Walter recoils, unable to take this. He relents.

INT. APARTMENT LIVING ROOM—ANOTHER DAY

*Another PHOTO OP, but big: A CAMERA CREW rushes about. Lights
get set up. Walter, Margaret, and Jane work at easels. Walter dabs at a
Big Eye. Margaret works on a sad, long-neck blonde. Jane paints a goofy
flower, like any child.*

Dick Nolan takes notes.

DICK

So you're now called "The Painting
Keanes"?

WALTER

Yep! Walter and his girls! With galleries
in three cities!

DICK

I had no idea Margaret painted.

WALTER

Yeah, we don't talk about it. Sadly, people
don't buy lady art.

MARGARET
(interjecting)
What about Georgia O'Keefe?

Dick shakes his EMPTY GLASS, distracted. Walter points.

> WALTER
> The bar's over there.

Dick goes to get a refill. Walter shoots Margaret a look.

> WALTER
> Yeah, Margaret's a superb artist, in her
> own way. I even steal a few tips from her,
> now and then!
> *(he chuckles)*
> Behind every great man is a great woman.

> DICK
> True true. So, Margaret, where do you get
> your ideas?

> MARGARET
> *(a bit tentative)*
> Oh . . . from the world around me. And I
> love Modigliani's use of line.

> DICK
> Modi-WHAT? The Italian joint?

> WALTER
> Oh, for Christ's sake, Margaret! Dick
> writes a gossip column—
> *(beat)*
> Let's stick to the family angle. Get a gan-
> der at little Janie over there!

Walter steers Dick to Jane, cute at her little child's easel.

> WALTER

What a talent! Look at these Keanes!
If you cut open our veins, we bleed *oil*!
Er—turpentine.
> *(awkward)*
Uh, Dick, you know what I'm goin' for.
Make it sound good.

DING-DONG! It's the doorbell. Everyone turns.

> JANE

Who's that?

> WALTER

Ah! A little treat! The fourth member of
the Painting Keanes!

Margaret and Jane turn, confused. Walter whips open

THE FRONT DOOR

revealing LILY, 10, a quiet girl in bobbed hair. She holds a little over-night bag.

A Buick HONKS, and Walter waves as it drives away. Walter stares at the girl, then puts on big hammy airs.

> WALTER

Lily, honey, how are you?!

He gives her a giant hug. She responds stiffly—a girl who doesn't see her father too often.

> LILY

I'm fine, Dad. I lost a tooth.

> WALTER
>
> Really? Did you get in a fight?

> LILY
>
> *(she laughs)*
>
> No. It fell out!

ANGLE—MARGARET AND JANE

They gape in bewilderment. Who the hell is this girl??!

BACK ON WALTER AND LILY

Walter admires Lily's mouth.

> WALTER
>
> Well is the tooth fairy somethin' *I* gotta
> deal with, or did your mother already
> handle it?

> LILY
>
> *(dry)*
>
> She handled it.

> WALTER
>
> Good! Good good! Well, just go throw
> your stuff in the kids' room, then you can
> come join the fun!

Lily toddles out.

ON THE GROUP

Margaret and Jane are speechless.

Walter acts like nothing bizarre has happened.

Dick eyeballs all this with major curiosity.

> DICK
>
> Walter . . . you never told me you had
> another daughter.

> WALTER
>
> Didn't I? Sure. Lil's from my first mar-
> riage.

Margaret struggles to hold her rage. Disoriented . . .

> MARGARET
>
> Walter?
> (*urgent*)
> Walter! We need to speak.

Margaret gestures: Get in the kitchen! He nods and follows.

INT. KITCHEN

Margaret shuts the door, then spins on him.

> MARGARET
>
> *What is going on here??!*

> WALTER
>
> That's Lily. I'm sure I mentioned her—

> MARGARET
>
> *No you didn't.*

Margaret peers at him. How much can she trust?

> Did she just move in??

 WALTER
 No! Her mom's just going to Vegas for
 the weekend.
 (beat)
 I'm supposed to have her once a month,
 but I don't make her mom enforce it.

TIGHT—MARGARET

Her head is spinning.

 MARGARET
 How can you keep something so big a secret???

TIGHT—WALTER

He starts to answer . . . then gives her a look: You are kidding?

Walter squirms defensively.

 WALTER
 She's a sweet girl.

 MARGARET
 (hissing)
 I'm sure she is.

 WALTER
 I put up with *your* daughter. I never said
 a peep.

Margaret's jaw drops.

 MARGARET
 I'm gonna pretend you didn't say that.

 WALTER
 I'm sorry. Sorry! Please . . . let's just try to
 get through this.

 CUT TO:

INT. JANE'S BEDROOM—NIGHT

Jane's room, cute with stuffed animals and troll dolls.

*Lily is in the corner, awkwardly unpacking her bag. Trying not to impose
on Jane's space. The girls peer at each other.*

 LILY
 Dad told me you had a bunk bed.

Jane shakes her head. She feels bad.

 JANE
 Take the bed. I can sleep on the floor—

 LILY
 No, that's not fair! The floor's fine for me.

Jane smiles nervously. She stares at this new girl.

 JANE
 Do you live far away?

 LILY
 I guess . . . about a twenty-minute drive.

 JANE
 (startled)
 Twenty minutes?! That's close!

Jane blinks, confused.

 JANE
But you never see Walter?

 LILY
No, I see him all the time! He comes up
and visits every week.

Jane is taken aback. Lily sees this.

 LILY
Doesn't he talk about me?

 JANE
 (lying)
Huh? Uh . . . sure. I guess a little.

Jane thinks, fretting.

 JANE
Does he talk about *me*?

 LILY
 (lying)
Uh . . . yeah. Sometimes.

 JANE
 (pleased)
So what's your mom like?

 LILY
She's pretty. She drives a Buick. She cries a lot.

 JANE
Yeah, mine's the same.
 (beat)
Except she drives a Packard.

Lily nods. Jane lowers her voice naughtily.

> JANE
> I have some peanut butter hidden in my
> sock drawer. Do you wanna eat it?

Lily smiles: Sure. Jane opens a drawer and removes a jar of Skippy. The two girls sit on the floor, happily eating the peanut butter with their fingers.

CUT TO:

EXT. KEANE GALLERY—NIGHT

Klieg lights streak the sky! A crazed CROWD is packed INSIDE. A big sign announces: "NOW APPEARING: AMERICA'S FIRST FAMILY OF ART—'We paint truth and emotion.'"

INT. KEANE GALLERY—NIGHT

The place is filled with Big Eyes. Waifs waifs waifs! Cash registers RING. Money changes hands. "Sold" stickers go up.

Walter works the room.

> WALTER
> Yeah, Walter Keane and Gauguin have a
> lot in common. They both walked away
> from successful careers to travel the globe,
> live on a boat . . .

We move . . . finding Margaret alone in a small ANNEX. It displays a few of her sad blondes, alongside Jane and Lily's paintings of flowers and Mr. Potato Head. Margaret sits, seeming like an adult at the children's table.

An urbane RICH MAN glides by . . . and is taken with one of Margaret's nubile blondes. He gazes at the lounging figure.

Margaret sits up. Alert, pleased with his interest.

She tingles. Then, happily excited, unable to hold it in:

> MARGARET
>
> *I* painted it!

> RICH MAN
>
> *Really?*
>> *(impressed)*
>
> It's very evocative. . . . Sensual . . .

He smiles flirtatiously. She smiles shyly and shrugs.

He steps forward—then peers closer at the painting. The SIGNATURE is a feminine scroll: "MDH Keane"

> RICH MAN
>
> "MDH"? You're so . . . *mysterioso.*

> MARGARET
>
> Yes, we don't use my name, since people don't take women's art seriously.
>> *(beat)*
>
> "MDH" are my initials. And more! I'm interested in numerology . . . and as you know, seven is a very good number.

> RICH MAN
>> *(puzzled)*
>
> Er . . . seven?

> MARGARET
>
> Luckily, my maiden name is Margaret Doris Hawkins! "M" is the thirteenth let-ter of the alphabet, "D" is four, "H" eight!

If you add up one and three in thirteen,
that gives you four, making four plus four
plus eight equals sixteen, then one plus
six equals seven!

The man's head is spinning. He's lost all interest.

Across the room, Walter sees this debacle. He marches over.

> WALTER
> Psst! Maggie! Can I have a second?
> *(he PULLS HER ASIDE)*
> Good grief! What the hell are you bab-
> bling about?! Long division?? Could you
> please help the world and *shut your mouth*?
> You want just one number in his head: the
> sales price!

Her face drops, hurt. Acquiescing.

WATCHING THIS

Two SNOBBY ARTISTS smirk and GROAN at this scene.

> SNOBBY ARTIST #1
> Two nuts that fell from the same tree! It's
> insufferable. Why are we starving, while
> they print money?

> SNOBBY ARTIST #2
> Because that nut's a *genius*! He sells paint-
> ings! Then he sells pictures of the paint-
> ings! Then he sells *postcards* of pictures of
> the paintings.

They stare bitterly. Then, a terrible, shameful idea forms:

> SNOBBY ARTIST #1
>
> I'll bet I could bang one out in ten minutes.

> SNOBBY ARTIST #2
>
> It wouldn't have the dopey sincerity.

> SNOBBY ARTIST #1
>
> The customers won't notice . . .

They peer sheepishly at each other . . .

CUT TO:

EXT. STORE WINDOW—DAY

Ruben is walking past—then stops, pained. A window display of Keane Big Eyes shares space with paintings of CUTESY KITTENS lapping up milk.

We WIDEN, revealing a whole wall of rip-offs! All with odd anonymous signatures: "Gig." "Eve." "Igor." A cavalcade of WIDE-EYED ANIMALS AND KIDS . . . DANCING WITH GUITARS . . . DRESSED AS HOBOS . . . PLAYING IN PAJAMAS. But these children aren't sad. They're just . . . blank.

Ruben gasps at the dead-eyed pictures.

> RUBEN
>
> Christ. It's a movement.

CUT TO:

INSERT—TELEVISION—FULL FRAME

"The Tonight Show" opening CREDITS:

ANNOUNCER (V.O.)
It's "The Tonight Show!" With guests
Jerry Lewis, the Everly Brothers, artists
Walter and Margaret Keane—

The CHANNEL CHANGES: A children's toy commercial (STOCK).
A tear-streaked, crying plastic DOLL, a flagrant Waif rip-off:

FEMALE ANNOUNCER (V.O.)
She's "Little Miss No Name," the doll
with the tear. From Hasbro.

The CHANNEL CHANGES: Spanish TELEVISION. A Keane
painting gets hung in Madrid's National Museum of Contemporary Art.

CUT TO:

INT. PAINTING ROOM—DAY

The Margaret sweatshop is going full-blast. Canvases are everywhere:
Melancholy MDH ladies. Woeful Keane kids. Even a portrait of Natalie
Wood, copied from a photo. Margaret dips a tiny brush, quickly detailing
the tear on a child's cheek . . . when the doorbell CHIMES.

Hm? Margaret puts down her brush, wipes her hands, then hurries out. She
opens the door . . . REVEALING THAT WE'RE IN A DIFFERENT
HOUSE. A GIANT, PHENOMENAL 1960s EXTRAVAGANZA.

INT. WOODSIDE HOUSE—SAME TIME

Margaret runs across the marble floors, past the swooping, modern lines of a
California ranch . . . all-white furniture . . . a kidney-shaped pool glisten-
ing blue outside the glass . . . a cute TOY POODLE barking at the door.

MARGARET
Rembrandt, shush!

In the foyer, Margaret opens the front door. And standing there is Dee-Ann. Dazzled. She laughs with surprise.

> DEE-ANN
>
> My God! I thought I misread the address.

> MARGARET
>
> Yeah. That driveway *is* long.
> *(she giggles, embarrassed)*
> Honestly, I can't believe I live here.

Dee-Ann glides in—then freezes, agape.

> DEE-ANN
>
> Whoa.

> MARGARET
>
> I know! Two acres, a pool, five bed-
> rooms—
> *(pause)*
> Though I thought that was excessive,
> since there's only three of us here.

> DEE-ANN
>
> Three? I thought there were four.

> MARGARET
>
> What?
> *(confused; beat)*
> Oh—you mean Lily! No, she doesn't
> really live with us. That was just in the
> articles.

> DEE-ANN
>
> Crazy. A fake daughter . . .

Dee-Ann's eyes take it all in. Astonished.

> DEE-ANN
>
> It's been so long since I've seen you.

> MARGARET
>
> I know. North Beach is thirty miles, but
> it might as well be three hundred . . .

> DEE-ANN
>
> You're probably busy, hanging out with
> your new rich buddies.
> > *(barbed)*
>
> *Kim Novak.*

> MARGARET
>
> Oh, please! She's Walter's friend.
> > *(a quiet shrug)*
>
> He brings people by . . . the Beach Boys
> were here. But, it's pretty isolated.

Dee-Ann goes silent. Margaret seems dwarfed by the house.

> MARGARET
>
> Jane has nice friends. Sometimes I pick
> them up at the junior high, and we all get
> pizza.
> > *(awkward)*
>
> But she's busy . . . Are you hungry?

> DEE-ANN
>
> I'm thirsty.

> MARGARET
>
> Good! I'll whip us up two gin fizzes.

*Margaret forces a smile and scurries behind a giant curved wet bar. She
pulls out ingredients: gin, lemon juice, soda . . .*

> MARGARET
> When we moved in, I thought a wet bar
> was extravagant . . . but it's surprising
> how much use you can get out of it.

Dee-Ann watches the drink-making.

> DEE-ANN
> How's Walter?

> MARGARET
> He couldn't be happier. He has everything
> he ever dreamed of.

> DEE-ANN
> And so do you! Fabulous.

*Dee-Ann smiles archly. She glances away—and notices Margaret's STU-
DIO, the door half open.*

> DEE-ANN
> Oh, is that your studio?

Margaret turns—and gasps.

> MARGARET
> No—! You can't go in—

> DEE-ANN
> I just want a peek. See what the workspace
> of a wildly successful artist looks like—

> MARGARET
> Dee-Ann, please! STOP—

Margaret rushes to block her—but Dee-Ann pushes open the door, revealing . . .

INT. PAINTING ROOM

A room full of MDHs and Keanes.

Dee-Ann stops, puzzled. She glances at Margaret—who has turned as white as a ghost.

Immensely curious, Dee-Ann slowly enters. She peers around at the two styles of paintings . . .

A strained silence. Finally, Margaret whispers.

> MARGARET
> W-Walter paints in here too.

Hmm.

Dee-Ann walks about, examining the canvases. Then, her gaze settles on the Big Eye that Margaret was working on.

Below the easel is the wet brush on the open jar of paint.

Margaret sucks in her breath. Dee-Ann sees this.

> DEE-ANN
> Is Walter home??

Margaret has no answer.

The two friends look at each other . . . Dee-Ann waiting . . . wondering if Margaret is going to lie to her . . .

When . . . SLAM!

WIDE

Both women startle. FOOTSTEPS. Then . . . Walter strides in!

Margaret's eyes pop.

Walter's pop even bigger. He glares at the ladies.

> WALTER
> What the hell's going on here?!!

> MARGARET
> *(timid)*
> Uh . . . Dee-Ann was just . . . she . . .

Margaret trails off. Walter thinks, then SNAPS.

> WALTER
> You KNOW I don't like anyone seeing
> my work before it's done!

Walter rushes to the Waif, then for show grabs up the wet brush and quickly starts to "finish" the painting.

Suddenly—an odd expression crosses his face. He eyeballs the canvas, realizing he doesn't know what to do.

A furtive glance. Then, unbowed, he hastily dips the brush and slaps a little black onto the shaded background.

Walter spins, victorious.

> WALTER
> There!

Walter gets between Margaret and her good friend Dee-Ann.

CUT TO:

INT. LIVING ROOM—LATER

The three sit silently, tension thick, sipping gin fizzes.

Nobody speaks.

Walter finishes his drink and pours a fresh one.

CUT TO:

INT. FOYER—NIGHT

They are drunk and SCREAMING. Walter pushes Dee-Ann out the door.

> WALTER
> You and your whole non-representational
> crowd are FRAUDS!!

> DEE-ANN
> SHUT UP! You're so full of shit, Walter!

> WALTER
> Get outta my house! My *big* house!
> (livid)
> Go back to sellin' your coat hanger sculp-
> tures on Fisherman's Wharf!

> DEE-ANN
> Fuck you!

Dee-Ann staggers outside, then hops in her car.

OUTSIDE

Dee-Ann GUNS the engine and squeals away. The car peels down the very long driveway.

Margaret and Walter watch the car disappear into the distance.

Without looking over, Walter speaks.

> WALTER
> I don't want her ever invited here again.

Margaret nods, terribly sad.

> MARGARET
> I won't.

CUT TO:

INT. MASTER BEDROOM—LATE NIGHT

Margaret and Walter lie in bed, awake. Arms crossed. Unspeaking.

EXT. WOODSIDE HOUSE—ANOTHER DAY

Margaret and 13-YEAR-OLD JANE play on the lawn with the poodle. Jane laughs as the dog chases in circles.

> JANE
> Go, Rembrandt! Get the ball!

She tumbles, and Rembrandt licks her ear. She giggles.

> MARGARET
> Okay, honey. I have to go work.

> JANE
> Can I come?
> *(an awkward silence)*

No. I can never come. No! I shouldn't
even ask.

Jane glares glumly.

Margaret peers hopelessly at her daughter . . . then goes inside.

INT. WOODSIDE HOUSE

*Margaret strolls to her studio. WE SEE the poodle scampering behind her
on its cute little legs. She enters the*

INT. PAINTING ROOM

*Margaret doesn't notice the tiny dog follow her in. She LOCKS the door,
then turns—surprised.*

> MARGARET
> Where did you appear from? Didn't you
> hear? No visitors!

Rembrandt wags his tail, his little eyes bright. Margaret peers.

> MARGARET
> Is this what it's come to? You're the only
> living soul I can tell my secret?
> *(she lowers her voice)*
> Well—I painted them *all*!
> *(she shudders with release)*
> It's TRUE! I did every single one—

She gestures, then catches sight of a Walter street scene.

> MARGARET
> Well, every one except that street scene.
> *(beat)*

But I did the rest. Every Big Eye! And
nobody will ever know. But YOU.

Rembrandt pants and BARKS.

*Margaret chuckles, then goes to work. She pulls a CURTAIN across the
sliding glass door. At her easel, she squirts a tube into a well and starts
mixing colors.*

Rembrandt jumps on the couch.

> MARGARET
> No you don't! It's nice to have company,
> but that sofa is new.
> > *(she pushes him off)*
> Let's find you some carpet to lay on.

Margaret goes over to a CLOSET. Rembrandt follows, curious.

IN THE CLOSET

*Margaret turns on the bare bulb inside. It's filled with old easels . . .
cans . . . junk . . .*

> MARGARET
> I think there's a scrap back here . . .

*She rummages, sliding the junk aside. In back is a TATTERED WOOD-
EN CRATE.*

Hm?

> MARGARET
> Well what's this?

*Margaret swings the bulb closer. The crate is covered with SHIPPING
INSTRUCTIONS and international markings.*

Margaret's interest is piqued. She tugs at the lid, pulling it off. Revealing inside a STACK OF STREET SCENE PAINTINGS. Ten or fifteen of Walter's canvases.

Or so it seems.

TIGHT — MARGARET

She peers closer.

TIGHT — THE PAINTINGS

The top painting is a typical Parisian street scene: cobblestones, a man carrying baguettes, an old lady selling roses . . .

But down in the bottom corner is the signature: "S. CENIC"

TIGHT — MARGARET

She sucks in her breath, shocked. She examines the painting.

Then, she hurriedly grabs the next canvas. It's another sunlit scene: A quaint Parisian café, a man playing accordion, and in the bottom right corner . . . the signature: "S. CENIC"

WHAT?! Margaret grabs the next canvas. "S. CENIC"

The next canvas.

The next canvas!

They all are signed "S. CENIC."

Margaret starts hyperventilating.

She thinks, then suddenly bolts from the closet.

INT. PAINTING ROOM

Margaret races, rushing up to Walter's painted street scene, hung on the wall. We PUSH IN TIGHT, as she shoves her face up to the canvas, so close we can see the brushstrokes—

As we MOVE IN TO THE SIGNATURE. Simply, "W. KEANE."

Margaret's face is flushed. She gazes at the name . . . then rushes back to her work area. She manically hunts: brushes, tubes, rags—and an EX-ACTO KNIFE.

Ah! She runs back to Walter's painting. Heart pounding, she grazes the knife up against the signature, then DIGS.

And—the "W. KEANE" flecks off. Revealing . . . underneath . . . the name "S. CENIC."

CLOSE-UP—MARGARET

She trembles, overcome. Music SWELLS. Her eyes spin back—

SERIES OF QUICK FLASHBACKS:

Walter painting at the Palace of Fine Arts. His canvas is blank.

Walter in the apartment, signing his name to a finished piece.

Walter spattering paint on his clothes.

Walter the day we met him. He shows off a rack of finished paintings at the Sunday Art Show.

BACK ON MARGARET

She collapses.

CUT TO:

INT. WOODSIDE HOUSE—THAT EVENING

A grandfather clock says 10:15. Margaret sits gloomily, staring at the clock. Clutching a drink.

LATER

2:30 a.m. Margaret still stares at the clock. She's stewing.

Suddenly, keys in the door. Walter swings in, tanked and full of life. He skids across the marble, humming to himself—when—he's startled by his wife. He jerks.

> WALTER
> M-Maggie! What're you doin' up?

Margaret glares. Not speaking. He shrugs.

> WALTER
> I had a helluva night. Worked three or
> four clubs.
> > *(he winks, loosey-goosey)*
> Stumbled onto some hot gossip: Madame
> Chiang Kai-shek is coming to town!
> Straight from Taipei! I think we should
> present her with a painting—get Dick to
> flack it . . .
> > *(he thinks)*
> Or the heck with Dick. I met a new guy
> at UPI . . .

> MARGARET
> Maybe you should give her one of your
> street scenes.

WALTER
(*hazy*)
You think? I dunno—I thought you could
whip off a doodle of Chinatown. With a
cute little kid, sort of a big-eyed slanty-
eyed thing . . .

Margaret's anger is raging. She glares, steely.

MARGARET
No, Walter. She's a dignitary. Doesn't she
deserve a piece that comes straight from
you?
(*sharp*)
From your experience???

WALTER
Yeah? Maybe you're right. She probably
doesn't have a Parisian street scene hang-
ing in her palace.

*Margaret nods, as if they've settled something. She turns to walk
away—then suddenly SPINS.*

MARGARET
Unless Madame Chiang Kai-shek already
has a Cenic.

ON WALTER

He freezes up.

Suddenly sober, smacked to reality.

WALTER
"Cenic" . . . ? Uh, what's that?

Margaret stares, eyes sharp.

> MARGARET
>
> Cenic is the name of the artist who did all
> your early paintings.

> WALTER
>
> Huhhh?
> *(spinning his lie)*
> Urgh . . . oh! CENIC!
> *(he laughs crazily)*
> Cenic was my nickname in Paris! All my
> art school pals loved my scenic views, so
> they called me "Scenic"! But since those
> Frogs can't pronounce a hard "e," I became
> "Cenic."

He looks up at her hopefully.

But she shakes her head.

> MARGARET
>
> The more you lie, the smaller you seem.

> WALTER
> *(unyielding, scrambling)*
> How DARE you accuse me of lying! I'm
> proud of my early Cenics!

> MARGARET
>
> Then why do you paint over the name?

Walter gasps, floored.

Margaret bores in.

MARGARET

A bit of advice: Don't use a water-base
over an oil. It flecks off.

Walter cowers.

WALTER

You sound crazy! For God's sake.
You've . . . you've SEEN me paint!!!!

MARGARET

No, I haven't.
(*quiet; strong*)
I always thought I had . . . but it's some
kind of . . . mirage. From a distance you
look like a painter, but up close . . . there's
nothing there.

CLOSE-UP — WALTER

All life drains from his face. His eyes go glazed. He speaks mechanically.
Tiredly . . .

WALTER

I studied art in Paris. I went to school at
the Beaux-Arts. The Grand Chaumiere. I
spent hours in the Louvre, gazing at the
greatness of the Masters . . .

MARGARET

Walter?

He turns. She winces, pained.

MARGARET

Have you even *been* to Paris?

Walter blanches. He shakes, broken up.

He looks away, then staggers to a chair. He falls into it. Trembling. Not able to look her in the eye . . .

WALTER
I wanted . . . I so wanted to be an artist.
But—it just never turned out good.

Margaret stares, seething.

Then, without comment, she storms away. She SLAMS the door shut. BANG!

Walter doesn't move.

CUT TO:

INT. KITCHEN—NEXT MORNING

Margaret makes Jane breakfast, scrambling up eggs.

Jane glances over her shoulder—and notices Walter in the living room, asleep on the couch.

An awkward pause. Jane says nothing.

INT. MASTER BEDROOM—LATER

Margaret is making the bed. Straightening the pillows.

In the b.g., Walter silently creeps into view. Shamefully standing in the doorway. Not speaking . . .

Margaret knows he's there, but doesn't acknowledge his presence. Finally, without making eye contact—

> MARGARET
> I don't want you sleeping in this room any
> longer. I—I can't keep living these lies.
> *(sharp)*
> There's three extra bedrooms. Go pick
> one.

He nods.

INT. HOUSE—LATER

*Margaret sits, unmoving, trapped in the big house. Outside, a JAPA-
NESE GARDENER trims the hedges.*

*Margaret stares at the walls, a smothering Walter Hall of Fame: Framed
magazine articles on Walter, smugly posed with the Waifs.*

*She swallows, then gently opens a dresser drawer. Inside is an ORIGI-
NAL WAIF from long ago. A small oil of Jane, when she was a toddler.*

Margaret stares . . . and then her face slowly crumbles.

INT. PAINTING ROOM—DAY

*Margaret huddles with a SKETCHPAD. Rembrandt is at her feet. She's
drawing. She looks up, as Walter anxiously enters. He's holding a drink.
He clears his throat.*

> WALTER
> What are you working on?

> MARGARET
> A new MDH. Something for *me*. It's about
> a woman trapped in an uncaring world. I
> call it, "Escape."

Walter bites his lip, afraid to talk.

> ### WALTER
> I figured out a solution to our problems.

> ### MARGARET
> What?

> ### WALTER
> Teach me.
> > *(beat)*
>
> Show me your tricks. Then you can pass
> off the Waifs, and we won't be lying
> anymore.

She looks up in disbelief.

> ### MARGARET
> And then—YOU'LL paint them?

> ### WALTER
> Sure! Why not?

> ### MARGARET
> > *(offended)*
>
> Walter, this isn't paint-by-numbers!
> You think it's easy?! It took me years to
> learn—

> ### WALTER
> Y-you're right!
> > *(sheepish)*
>
> But you know me! I'm a quick study. And
> I've got the basics . . .

He trails off, unsure where this is going.

Trying to rouse her, Walter rushes to an easel and throws up a blank canvas. She eyeballs him.

> MARGARET
> If you knew the basics, you wouldn't be at
> the easel. You have to *sketch* it first!

Walter tightens, feeling stupid. He lets go of the canvas.

Margaret stares, deciding. Then, she tosses him a PAD.

Walter catches it. Slowly, he crosses over . . .

ANGLE—MARGARET AND WALTER

They peer at each other, like a Mexican standoff. Then, he nervously picks up a pencil.

> WALTER
> So . . . ? What's first?

> MARGARET
> I dunno. You tell me. You're the creator.

He frowns.

> WALTER
> It's a—Keane.

> MARGARET
> Oh, a Keane! How witty.
> (sarcastic)
> You know, when we met all those years
> ago, I never would've imagined in my
> wildest dreams that one day—

WALTER

YEAH YEAH! Point taken. I'm standing
here naked and humiliated in front of you.
Look . . . can we just do a crying child?

She gazes at him. Fingering her pencil . . .

Trying to jump-start things, he starts to draw a circle—

MARGARET

How old is the subject?

WALTER

Huh? C'mon, it's a head—

MARGARET

It matters! A young child's head is round.
An older child's head is oval!

He feels pressured. Hand shaking, he draws a crooked circle.

WALTER

The child is *this* old!
(*angry*)
You're trying to make this difficult—

MARGARET

NO I'M NOT! Every line is a decision!
(*impassioned*)
It's easy to talk about art, but it's not easy
to MAKE art!!

DISSOLVE TO:

INT. PAINTING ROOM—MONTAGE:

Margaret easily outlines a head, then two circles for eyes.

Walter tries copying, but his eyes are misshapen.

Again, Walter copies, but he's wobbly. Angry, he scratches it out.

Margaret tries to help, guiding his hand. Insulted, he pushes her off. He CRUMPLES the page.

NEW TACTIC: Walter grabs her sketch. He puts it on a LIGHT-TABLE. Despairing, he starts to trace it . . .

LATER

Walter finally paints. We can't see the canvas, but he's very meticulous. His expression quite earnest. He adds a final flourish . . . and then . . . a flicker of pride crosses his face. He smiles.

We slowly MOVE AROUND . . . to REVEAL HIS PAINTING. And . . . it's . . . absolutely dreadful. Kindergarten quality.

Walter stares.

Then, he furtively glances at Margaret's work. Comparing . . .

The realization slowly sinks in. He has no ability.

A sadness swells into fury . . . and suddenly Walter GRABS HIS CANVAS and SMASHES IT AGAINST THE EASEL. CRASH!! The canvas SHREDS. The frame blasts into pieces!

Walter spins. He glares at one of Margaret's finished Waifs . . . then explodes, even more enraged. HE PICKS UP MARGARET'S PAINTING AND STARTS TO SWING IT AT THE WALL—

MARGARET (O.S.)
Walter!!

Huh? He lurches, startled.

ACROSS THE ROOM

Margaret stares him down.

Sweaty, chest heaving, Walter staggers toward her. His face scowls, untamed. He clenches his fist, like he might attack Margaret—

Then—he SCREAMS and smashes her CANVAS. BAM!!! The painting RIPS apart. Walter KICKS his foot through the remains, then spins and charges from the room.

CUT TO:

INT. KEANE GALLERY—DAY

TOURIST FAMILIES mill about. Suddenly the door SLAMS open. Walter bolts in, wild-eyed. A bit deranged.

The families gawk—glancing from Walter to his photograph all over: "WALTER KEANE! THE WORLD'S TOP-SELLING ARTIST!"

Walter ignores them. He rushes a buxom REDHEADED CLERK.

> WALTER
> How's SALES?

> REDHEAD CLERK
> Oh, you know. Mondays—

Walter MUTTERS strangely. He snatches some paper and starts scribbling. Then he runs into the

STORAGE ROOM

Walter agitatedly paces, circling the stacks of PRINTS.

WALTER

How many posters are back here?

REDHEAD CLERK

Exactly? I dunno, three thousand or—

WALTER

Does the printer owe us more? Do we owe him??

REDHEAD CLERK

Uh, let me—

WALTER

What about the OILS?! Are there more at
the warehouse?

REDHEAD CLERK

Mr. Keane, I'd have to make a—

WALTER

For the LOVE OF MUD! What am I
PAYING you for?

The girl freezes, rattled. Walter spins, flipping out.

WALTER

Hypothetical question: If you were a man,
would you marry Kim Novak or my wife?

What?

WALTER

Okay! Different question! If I got crippled
and had to stop painting, how long before
the gallery ran out of inventory and went
belly up??

REDHEAD CLERK
(*rattled*)
Do you want a glass of water, Mr. Keane?

Walter sighs. His thoughts drift away . . .

WALTER
What's it all mean? Why are we put on
this earth? A hundred years from now,
will people even know we existed . . . ?

REDHEAD CLERK
(*uncomfortable*)
I—I don't understand. You'll always
be famous. You were on the Jack Paar
Show . . .
(*she glances away*)
Er, excuse me, sir.

The girl hurries away, to ring up some customers.

Walter silently watches. At the register, the Tourists buy a print. A "Madonna and Child," MDH-style.

BAMMM! Walter's eyes bulge, like he's been stung.

WALTER
It's not even mine! It's one of *hers*.

Aching, he staggers off. Sweating, woozy, he sits at a table.

Distracted, he glances down at a newspaper . . .

INSERT—NEWSPAPER

*There's an article on the 1964 NEW YORK WORLD'S FAIR. A headline
says "CONSTRUCTION RACES TOWARD APRIL OPENING."*

TIGHT—WALTER

His eyes narrow, piqued. World's Fair??? He leans in . . .

CUT TO:

INT. BISTRO—NIGHT

A return to the charming bistro Margaret and Walter went to all those years ago, on their first date. The Maître d' BEAMS.

> MAÎTRE D'
> Ah! Monsieur and Madame Keane!
> Delighted! Always such an honor!

ANGLE on the Keanes. They are sullen. At wit's end.

AT THE TABLE—LATER

They stiffly sit at their old table. He snarls, eyes black.

> WALTER
> This doesn't change anything.

> MARGARET
> *(trying to hold her ground)*
> I know the truth.

> WALTER
> *Who cares?!* This is all your fault! Maybe
> it's time to shake things up. Start puttin'
> my name on the MDHs.

Margaret is astonished. A fury crosses her face.

———•———

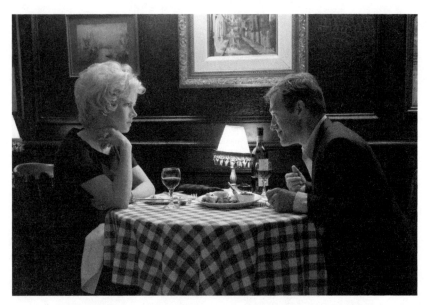

Returning to the scene of their first date, Walter threatens Margaret to keep her from telling the truth.

———•———

MARGARET

NO! Absolutely NOT!! I still hate myself
for giving you the Waifs!

WALTER

Quiet! Lower your voice—

MARGARET

Oh, I'll talk as LOUD AS I WANT—

WALTER

NO YOU WON'T! Or—
(flailing)
I'll have you whacked!

She jerks, flabbergasted.

MARGARET

What??!

WALTER

If you tell ANYONE, if you squeal, I'll
take you out! I—I know people. Remember
Banducci's cousin? The liquor wholesaler?

Pause. Margaret breaks into tears.

MARGARET

You're threatening me . . . ?! Fine, kill
me! My God, I've kept our secret for
years! I've never once—
(crying)
Do you know what it's been like for me? I
don't have any friends. I've lied to my own
child . . .

Margaret shudders, distraught. Mascara runs down her cheeks. Walter squirms, uneasy with this.

> WALTER
>
> Christ, wipe your face! You look a mess.
> *(beat)*
> It's life imitating art! A crying Keane!

He hands her his handkerchief. She dabs at her eyes.

A looming quiet.

> MARGARET
>
> What do you want, Walter? Everything
> with you is calculated. We're back where
> we had our first date . . .

Walter's eyes widen.

We MOVE IN TIGHT on them. He drops his voice. Dead serious.

> WALTER
>
> Look, I don't deny I need you. You're the
> one with the gift.
> *(beat; hushed)*
> Right now there's a shot . . . God, I'm
> shaking I'm so excited. The *New York
> World's Fair.* Seventy million visitors.
> Opening day, I unveil my MASTERPIECE!

She is flummoxed.

> MARGARET
>
> What masterpiece?

WALTER

Exactly! What have I been missing all
this time?! Da Vinci has his *Mona Lisa* . . .
Renoir has his *Boatmen's Lunch* . . . But
where's *my defining statement?*

MARGARET

You sound insane. Artists don't announce
a masterpiece—

WALTER

Why not?! Didn't Michelangelo know he
was hittin' a homer, when he was on his
back painting the Sistine Chapel?

MARGARET

He worked on that for FOUR YEARS!

WALTER

Posterity, baby . . . !!

She empties her drink.

WALTER

And here's the best part. It's for Unicef!
Unicef is sponsoring the Hall of Educa-
tion. Aw, we can finally give back to the
children of the world!!

Margaret stares, wavering . . .

CUT TO:

*STOCK FOOTAGE: The 1964 WORLD'S FAIR READIES TO
OPEN. Men on cranes hammer away. Fantastic, futuristic pavilions rise.
The Hall of Education gets erected . . .*

INT. PAINTING ROOM—DAY

ANGLE—An INSANELY BIG, BLANK CANVAS. It's eight feet across, filling half the room. Margaret is in the throes of hastily creating the MASTERPIECE.

Sketches are tacked everywhere. Margaret is chain smoking, sleep-deprived. The DESIGN is a staggering multiracial CROWD of children, mournful, extending to the horizon.

Walter enters, silently scrutinizing.

> MARGARET
> It's too big. Why'd you promise them
> Cinerama size?

> WALTER
> Because it has to encompass all children. All
> races! One hundred stricken faces! Marching
> to infinity! The *ultimate Walter Keane*!
> > *(beat)*
> At least that's what I told *LIFE* magazine.

Margaret ignores this. Walter does a rehearsed turn.

> WALTER
> Oh, a publisher says it's good timing to
> put out a coffee table book. You know,
> classy: *Tomorrow's Masters.*
> > *(awkwardly "casual")*
> So they need my . . . uh, early portfolio.
> My artistic evolution . . .

Margaret's eyes pop.

That's it. We PUSH IN . . . as she struggles to contain her frustration. Suddenly—she SNAPS.

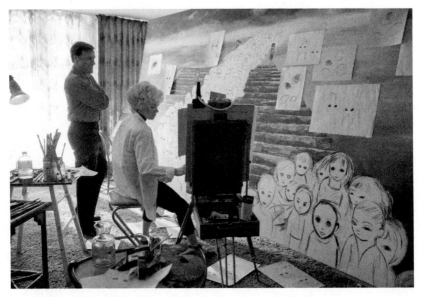

Walter pushes Margaret to paint his "masterpiece."

MARGARET
You're right! Where *are* your preliminary
sketches?? All that time in art school,
and somehow we waylaid your youthful
experiments! The half-finished charcoals,
the struggles . . .

WALTER
(a bit off-balance)
I know you're being sarcastic, but these
are all good ideas. Berlin war orphans . . .
early self-portraits . . .

Her eyes narrow.

MARGARET
Get out of here. I'm trying to *work*.

She brusquely spins away, back to the canvas.

He shoots her an uncertain, dirty look. What just happened?

CUT TO:

INT. HOUSE—NIGHT

Teenage Jane wanders through the house. Shouting.

JANE
Mom, what's for dinner?
(no response)
Mom! Are you home . . . ?

Nothing. No sign of Margaret.

Jane tries the door of the PAINTING ROOM. As always, it's locked. Hm . . .

Jane sneakily glances around. Opportunity. Quickly, she stands on a chair and reaches above the door sill. She feels around . . . and finds a KEY.

Ah! Hurriedly, Jane UNLOCKS the door and lets herself in.

INT. PAINTING ROOM—SAME TIME

The room is a madhouse of WAIFS. Jane takes it all in. Her face darkens.

Then, heavy breathing. She turns. Margaret is asleep, curled up under the almost-finished Masterpiece. Jane leans in. Slowly, Margaret rouses—then suddenly:

> MARGARET
> W-what are you doing in here—?
> *(blinking; half-awake)*
> This is—Walter's studio!
> *(discombobulated)*
> You have to leave!

Jane peers sadly at her mother.

> JANE
> Mom . . . I know.

> MARGARET
> Jane, you don't know anything!!

Jane's face tightens. Insulted.

> JANE
> I'm not a child anymore.

Angry, Jane runs out. Margaret stares after her—completely remorseful. She knows she did the wrong thing.

———— • ————

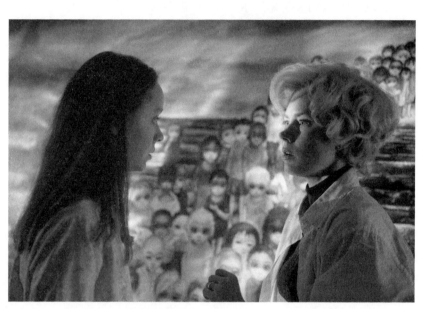

*Teenage Jane tearfully tells her mother that she knows Margaret is the
painter.*

———— • ————

Suddenly, she runs after Jane and grabs her tightly. Overcome, Margaret starts weeping. Jane starts crying too.

CUT TO:

INSERT—*LIFE* MAGAZINE

A gargantuan spread. The LIFE ARTICLE *is titled "The Man Who Paints Those Big Eyes." We PULL OUT* . . .

INT. *NEW YORK TIMES*—DAY

Starchy John Canaday reads the article, gaping in utter disbelief. His desk says "JOHN CANADAY, SENIOR ART CRITIC." He also has Walter's BOOK, Tomorrow's Masters Series. We WIDEN, revealing he's in the busy New York Times *NEWSROOM.*

> CANADAY
> Four . . . five . . . SIX pages! Is there
> something here I'm missing?
> > *(upset)*
> He's like—the Hula-Hoop! He just won't
> go away . . . !

He flips a page—then his jaw drops.

> CANADAY
> "Will be unveiled in the Grand Pavilion
> of the Hall of Education . . . internation-
> ally celebrated artist has been selected . . .
> will represent the aspirations of children
> worldwide—"
> > *(he GASPS)*
> Oh this is ABSURD!

He GRABS for his phone.

INT. WORLD'S FAIR HALL OF EDUCATION—DAY

A panel flicks, and the huge empty space lights up. It's overwhelmingly cavernous, a bright, freshly painted space-age spectacular. Up high hangs The Masterpiece and its one hundred kids. A sign says "TOMORROW FOREVER."

Below, two tiny figures walk in: Canaday and an obtuse CIVIC LEADER. Canaday stares up in horror. Utterly stupefied.

> CANADAY
> And WHO was on the selection commit-
> tee?

> CIVIC LEADER
> Oh! Well there wasn't a "committee," per
> se. We just had a luncheon with me, Ed,
> Jerome, Jerome's wife . . .
> *(he thinks)*
> Though technically, we didn't invite
> submissions. Mr. Keane just contacted us
> directly!

Canaday reacts, smoldering.

INT. NEW YORK MANSION—DAY

A STRING QUARTET PLAYS at a GRAND PARTY. It's complete-ly fabulous—an old-money mansion filled with stuffy BLUE BLOODS, all tuxes and gowns.

In the doorway appear Walter and Margaret. They're dressed to kill. Walter's radiant—but Margaret looks like she's about to emotionally dis-integrate. Suddenly, he WHISPERS.

 WALTER

Stop. Let us appreciate this moment. *This* is
what we've worked toward our whole lives:
Rarified air. Inside this house are the mov-
ers and shakers. Kennedys. Rockefellers.
 (misty-eyed)
Until today, we've always been on the out-
side, looking in. But when we enter . . .
we will belong.

 MARGARET

I was happier selling paintings in the park.

He gapes, appalled.

 WALTER

You are one crazy bitch.

*Walter spins and grandly enters. He grabs two CHAMPAGNES from
a server.*

 WALTER

So maybe you have problems with the
choices we made . . . but—c'mon!
Wednesday, the World's Fair opens.
Thursday, our book goes on sale!

 MARGARET

Friday, I file for divorce.

 WALTER

Aw, why are you always so miserable?
 (irritated)
Well, I'm gonna enjoy my afternoon!

The HOSTESS is a bejeweled dowager. Walter makes a beeline.

WALTER
Mrs. Teasdale! Walter Keane. I just want
to thank you for hosting this absolutely
enchanting soiree.

Walter takes the woman's hand. She smiles stiffly, silently horrified. She glances around for help.

She catches a SOCIETY MAN's eye, and he hurries over.

SOCIETY MAN
Hey, Keane. Have you seen the *Times*?

WALTER
Er, no. Honestly, I've been so busy all day
preparing for this lovely—

SOCIETY MAN
I think you should read the *Times*.

The Man gestures. Perplexed, the Keanes follow him into a

INT. DEN—SAME TIME

The room looks like a hunting lodge. On the desk are all the DAILY PAPERS. Walter grabs the NEW YORK TIMES—then gasps.

INSERT—*NEW YORK TIMES*

It's open to a reproduction of Tomorrow Forever, *above a scathing REVIEW.*

THE KEANES

stare, then turn pale.

INSERT—REVIEW

A BLIZZARD of WORDS assaults us:

> *"Grotesque"* *"Appalling"*
> *"Tasteless"*
> *"Lowest common denominator"*

MARGARET AND WALTER'S

faces drop, terribly hurt.

> MARGARET
> How could anyone . . . say something so cruel?

> WALTER
> *(a seething fury)*
> What do YOU care?! That's MY name
> being dragged through the mud!

Walter CRUSHES the newspaper. He spins on the guy.

> WALTER
> Is he here?

> SOCIETY MAN
> Er . . . yes. Which is perhaps why it
> would be best for everybody if you—

Walter STORMS out. The guy futilely chases—

INT. LIVING ROOM—SAME TIME

Walter barrels in. The ROOMFUL OF GUESTS are all staring.

> WALTER
> WHO WROTE THIS SHIT?

People cower.

Walter scans the crowd . . . and spots a cluster. Ah-hah! There is Canaday. Possessed, Walter strides over. Canaday stares, defiant. It's tense—until he clears his throat.

> CANADAY
>
> Mr. Keane, this is not the venue. Perhaps you'd like to write a letter to the editor.

Walter's throat tightens. He steps right into *the guy's face.*

Women GASP. Tension bristles—like a fight's about to erupt.

> WALTER
>
> What are you afraid of??
> (*malevolent*)
> Just because people like my work, that means it's automatically bad??

> CANADAY
>
> No. But that doesn't make it art either.

Walter shudders. Canaday asserts himself.

> CANADAY
>
> Art should *elevate*—not pander! Particularly in a Hall of Education!

> WALTER
>
> (*offended*)
> *You have no idea!* Why does a man become a critic—?? Because he can't create! You don't—

> CANADAY
>
> Ugh! That moldy chestnut—

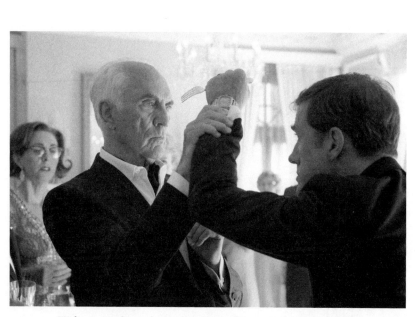

Walter responds to a bad review by attacking art critic John Canaday.

WALTER

Don't interrupt! You don't know what
it's like! To put your emotions out there,
naked, for the world to see.

CANADAY

What emotions?! It's synthetic hack work!
(*he loses it*)
Your "masterpiece" has an infinity of
Keanes—which just makes it an infinity
of *kitsch*!

Crazed, Walter grabs a FORK off the buffet.

He lunges, like he's about to STAB Canaday!

WIDE

Women SCREAM.

A few MUSCULAR MEN start to break through, to help.

WALTER

*looks around—then quivers, realizing he's out of control. Shamed, he
slowly drops the fork.*

People breathe a sigh of relief.

MARGARET

*is mortified. This is all too awful. Silent, she watches Walter back out of
the party . . .*

CUT TO:

INT. WORLD'S FAIR HALL OF EDUCATION—DAY

Tomorrow Forever gets TAKEN DOWN. Burly WORKMEN slide the painting into a huge WOODEN BOX.

INT. KEANE HOUSE—NIGHT

The house is dark. Walter is raging, in an alcoholic fury.

> WALTER
> What's wrong with lowest common
> denominators?! That's what this country
> was built on!!

He KNOCKS over a lamp. Crash!

> WALTER
> I'm gonna sue EVERYBODY! I'll sue
> that pansy critic! And the World's Fair!
> And—Unicef!
> *(crazed)*
> Yeah! I'll take down Unicef, and all their
> precious little boxes of *dimes*!

Walter RUSHES BY. In a dim alcove, we make out Margaret and Jane, huddled in the shadows.

Jane looks up at her mother with wide, frightened eyes.

Suddenly—Walter LUNGES at them!

They SCREAM, startled.

> WALTER
> But I can't sue *you*, can I?
> *(in Margaret's face)*
> You were the ultimate betrayal! You
> FAILED me with that painting!

Suddenly, he pulls out a BOOK OF MATCHES. He lights a MATCH and waves it sinisterly—

> WALTER
> You crossed over from sentimentality to
> KITSCH!

He THROWS the match at them.

> JANE
> Ow!

> MARGARET
> STOP IT!

He lights ANOTHER MATCH.

> WALTER
> You like making me look bad?? You enjoy
> people *laughing* at me??!

He PUNCHES the wall, then tosses the match. Fwoosh!

> MARGARET
> Walter!

He throws ANOTHER MATCH.

WIDE

Margaret grabs Jane and starts running.

They rush into the blackness.

Walter squints woozily, then starts to CHASE—

INT. HALLWAY

The ladies run for their lives.

Violent THUDS behind them!

Something SMASHES.

Margaret reaches the Painting Room. She YANKS Jane inside, then SLAMS the door!

Walter staggers up.

> WALTER
> LET ME IN!

INT. THE PAINTING ROOM

Margaret LOCKS the door. She backs away.

INT. HALLWAY

Walter tugs the door. He POUNDS it, crazed.

> WALTER
> Lemme in, you BITCHES!!

INT. THE PAINTING ROOM

Margaret and Jane shudder.

All around them, Big Eyes stare down from above.

INT. HALLWAY

In his haze, Walter remembers the hidden key. Raging, he drunkenly pulls over the chair, then stands on it.

But he's too wobbly—and falls.

Bam!

> WALTER

Ow!

INT. THE PAINTING ROOM

Margaret hugs Jane.

> JANE
> Mom, what are we gonna do??!

Margaret thinks.

INT. HALLWAY

Walter laughs crazily and lights another MATCH. It flickers.

> WALTER
> You got all that paint and turpentine in
> there? Well I'm gonna burn you up!

He pushes the lit match through the KEYHOLE.

> WALTER
> You're gonna blow like an atom bomb!

INT. THE PAINTING ROOM

The match drops on the floor—then goes out, harmless.

That's it. Margaret makes a decision.

> MARGARET
> We're leaving.

Determined, Margaret runs to the curtained wall. She whips it aside—revealing the sliding glass doors.

INT. LIVING ROOM—MINUTES LATER

Walter is lighting another match—when he spins. Through rheumy eyes, HEADLIGHTS orbit across the front window.

He peers, confused . . .

CUT TO:

INT. CAR—DRIVING—NIGHT

Margaret and Jane drive fast. Adrenaline pumping. Lights of the city flash across their faces.

> MARGARET
> I'm sorry I wasn't the mother I could have been.
> I—I should have done this years ago . . .

> JANE
> But where are we going?
> *(flummoxed)*
> We don't even have any clothes!

> MARGARET
> Where we're going, we won't need much.
> *(long pause)*
> Hawaii.

Jane freezes, not sure whether to believe.

> JANE
> Really . . . ?

Margaret smiles softly. We slowly PUSH IN to her.

> MARGARET
> Yes, Hawaii. Because it's paradise. There's
> flowers, and birds, and beautiful colors.
> *(gentle)*
> And . . . we're going to make a new life
> for ourselves.

DISSOLVE TO:

EXT. HAWAIIAN HOUSE—DAY

Hawaii, paradise indeed. A dense, tropical forest of deep greens and giant blooming flowers.

Margaret stands on the porch of her small, lovely house, breathing in the clean air. She looks lightened.

In a clearing, Jane plays with some LOCAL TEENS.

INT. HAWAIIAN HOUSE—SAME TIME

The house is simple. In one light-filled corner is an EASEL. Margaret is painting Nature: Splaying ferns. Wild succulents.

In the window, a BIRD flies by, its plumage a dazzling red. Margaret thinks—then takes out a tube of RED PAINT. She starts to apply the vivid color onto her canvas . . .

When—a RINGING PHONE. Margaret reacts, startled.

This is unexpected. And unsettling. It RINGS. RINGS. RINGS. Finally, she hurries to her one telephone, mounted on the kitchen wall. She slowly answers it.

> MARGARET

Hello?

> WALTER (O.S.)

Maggie—?

She freezes.

INTERCUT:

WALTER ON THE PHONE—WOODSIDE

He is strangely controlled and forboding.

> WALTER

Boy, you were sure hard to track down.
Thought I might never find you . . .
> *(a menacing chuckle)*
I'm a little agitated. I got the strangest
papers in the mail today.

Margaret tries to stay cool.

> MARGARET

It's a decree of legal separation. I would
appreciate if you signed it.

> WALTER

Aren't you acting too rash?

> MARGARET

Walter, our marriage is over.

> WALTER

Granted, our romance may have seen its
better days. The bloom is off the rose.

(*beat*)

But I'm looking out for both of us. What about Keane Incorporated?! We're a professional couple. Like Roy Rogers and Dale Evans.

MARGARET

Walter, I want a divorce.

WALTER

Whew. It hurts to hear you say those words.

Silence. He is feigning "hurt feelings." Struggling for a response. Finally, his thoughts sharpen up, smart and shrewd.

WALTER

I sure hate that it's come to this.
(*beat*)
Well . . . I SUPPOSE I can agree to a split—as long . . . as you assign me all rights to every painting ever produced.

MARGARET

If that's the price.

WALTER

Really?!

Walter is surprised. Greedy, calculating, he wonders if he can push her further . . .

WALTER

Uh—okay. And . . . then, we have to consider future revenue stream.

 MARGARET
My God, Walter! How much more money
do you need?

 WALTER
It's—the marketplace! I gotta stay fresh.
Surely you understand?
 (deadly)
You want me out of your life, here's my
term: You'll have to paint me a hundred
more waifs. One hundred more Walter
Keanes!

Margaret's face drops, pained. But she doesn't object.

 CUT TO:

EXT. HAWAIIAN HOUSE—DAY

*Margaret loads BUNDLED, WRAPPED PAINTINGS into a dusty
pickup truck. Jane comes running by, barefoot.*

 MARGARET
Would you like to go into town? I'm
stopping by the post office.

 JANE
No, I'm gonna surf with the gang.

Margaret tightens up.

 MARGARET
Your friends are a bit . . . wild.

JANE

(*she snaps*)

Loosen up, Mom! You're impossible! You
move me all the way to Hawaii. Then I
actually make some friends, and all you do
is complain about them.

(*cutting*)

Maybe *you* need to make some.

MARGARET

Y-you know I can't have people over to the
house.

JANE

That's right! Or they'd see the precious
paintings!!

Margaret has no response. Jane runs off.

INT. HAWAIIAN HOUSE—DAY

*Margaret is alone, pouring a drink. She mixes in some ice—then sees
something odd.*

OUTSIDE THE WINDOW

*Coming down the long driveway are two FIGURES. Two small WOM-
EN, patiently walking toward the isolated house.*

*Margaret stares, puzzled. The women come closer. They are Asian, dressed
in formal dresses. Curious, Margaret creeps over, spying on them . . .*

*They walk up and ring the bell. DING-DONG! An unsure beat . . .
then Margaret opens the door. The ladies smile politely.*

> ASIAN LADY #1
> Hello. We're visiting everyone in this neighborhood with an important message. No doubt you're busy, so we'll be brief.

Huh?

Margaret stares at them deadpan, highball in her hand.

> ASIAN LADY #2
> We have something to share with you about the wonderful things that God's Kingdom will do for mankind.

Margaret's face darkens.

> MARGARET
> I'm not interested.

She starts to close the door . . . but they continue.

> ASIAN LADY #1
> Do you mean that you are not interested in the Bible, or in religion in general?

> MARGARET
> I'm not interested in whatever you're selling.

The lady glances at Margaret's glass. She smiles gently.

> ASIAN LADY #2
> But we're not selling anything. We're just here to share the good news.

> MARGARET
> (*dour*)
> From where I'm standing, I don't see much
> good anywhere. Just a lot of pride, and thievery,
> and people treating each other poorly.

> ASIAN LADY #2
> Yes! Exactly! That is the good news!

What? Margaret is lost. The ladies grab the opening.

> ASIAN LADY #1
> Bad things in the world are a sign. They
> show us that earthly Paradise is at hand.

> ASIAN LADY #2
> Do you know what it says in Timothy 3:1–5?
> (*she pulls out a BIBLE and quickly thumbs to a page*)
> "In the last days, critical times hard to deal with
> will be here. For men will be lovers of them-
> selves. Lovers of money. Self-assuming, haughty,
> blasphemers, disobedient—"

> MARGARET
> Sounds like my ex-husband.

Margaret laughs. Surprised, the women laugh, too.

Margaret peers at them. At their Bible.

> MARGARET
> Would you like to come in?

CUT TO:

LATER

The three women sit. Margaret gazes . . .

> MARGARET
> It's been so long since I've been happy.
> But, I don't even know why I'm telling
> you . . . two complete strangers.

> ASIAN LADY #1
> It's our mission to comfort those in
> mourning. Jehovah wants us to help the
> brokenhearted.

> MARGARET
> So you're—Jehovah's Witnesses?

The ladies nod.

Margaret thinks.

> MARGARET
> I've explored so many religions. But they
> all had their flaws . . .

> ASIAN LADY #2
> Then they're wrong for you. Read your
> Bible—you might be surprised by the
> answers it gives.
> (*gentle*)
> Margaret, you can't go down a path unless
> you know, in your heart, it's the right one.

> MARGARET
> And how do *you* know . . . ?

ASIAN LADY #2
(she smiles)
Because our beliefs are supported by the
Scriptures. Jehovah is the God of truth.

Beat.

Margaret glances over at a half-completed "Keane" on the easel. A strange
pause.

MARGARET
What does that mean, exactly?

ASIAN LADY #2
(emphatic)
Honesty leads to self-respect. A feeling of
well-being.

Margaret is piqued. Her eyes widen. Like a Keane.

CUT TO:

INT. HAWAIIAN HOUSE—NIGHT

Margaret is enthralled, avidly perusing a happy-looking booklet, "The
Truth That Leads to Eternal Life."

MARGARET
It says here a worshiper of Jehovah must
be honest in all things.

Jane snorts.

JANE
I just can't believe you let people in the
house.

MARGARET
I have nothing to hide!
(torrid)
It also says *no lies.* "Speak truth. Let the
stealer steal no more."

Margaret and Jane lock eyes.

CUT TO:

INT. WOODSIDE HOUSE—DAY

*Loud JAZZ plays. Back home, Walter is living a Man's, Man's World.
He's partying, drinking, and dancing with two cute HIPPIE CHICKS
in bikinis.*

The place is like a WAREHOUSE, Keane PRINTS stacked everywhere.

HIPPIE CHICK
Shit, this is crazy! All these copies . . .
you're like Warhol!

WALTER
Nah, Warhol's like *me.* That fruit fly stole
my act! "The Factory"? I had a factory
before he had a soup can!

The girls scrunch their faces, lost.

Then—DING-DONG! Walter peeks out the window, then grins.

WALTER
Ah! It's my art supplies.

INT. PAINTING ROOM—SECONDS LATER

Alone, Walter eagerly pries open a GIANT CRATE. He pulls out padding. Wadded Honolulu newspapers. Then . . . a PAINTING.

Ah! A new WAIF, surrounded by colorful tropical plants. Walter smiles triumphantly—until—his happiness melts into confusion. Then horror.

We ZOOM IN ON the painting's SIGNATURE. It says "MDH Keane."

Walter freaks.

> WALTER
> AAAGGGGHH!

> CUT TO:

INT. HAWAIIAN KINGDOM HALL—DAY

The JEHOVAH'S WITNESSES sing a joyous, high-spirited PSALM:

> JEHOVAH'S WITNESSES
> "Tremble not before your foe,
> Let all lovers of truth know!
> That my reigning Son, Christ Jesus,
> From the heav'ns has cast the foe.
> Soon will bind the Devil, Satan,
> Letting all his victims go!"

Margaret and Jane are singing happily.

INT. HAWAIIAN HOUSE—DAY

Margaret pours her liquor down the sink.

Margaret tosses her cigarettes in the trash.

Margaret swells, feeling a burst of power. Then a VOICE:

> D.J. (O.S.)
> Oh yeah! We got a special guest today. A
> world-famous celebrity who just called up
> and asked to come in . . . !

INT. RADIO BOOTH—DAY

Angle on BIG LOLO, a gregarious Hawaiian D.J. in headphones.

> D.J.
> She's *malihini*! Moved to the islands a
> couple months ago . . . so let's give a big
> aloha to Margaret Keane!

He pops in a cart. Canned APPLAUSE plays. We reveal across from him . . . Margaret. He grins.

> D.J.
> So is it true your husband Walter is the
> top-selling painter in the world?

We SLOWLY PUSH IN to her. Tentative, she speaks.

> MARGARET
> No . . . Big Lolo. Everything you just said
> is false.

Margaret takes a deep breath. Working up her courage.

> MARGARET
> One: Walter is no longer my husband.
> *(a long pause)*
> And two: He's not . . . a painter.

Margaret exhales.

The D.J. is confused. He checks his notes.

> D.J.
> But, am I . . . mixed-up? Ain't he the guy
> who does the crazy eyes?

> MARGARET
> No. Though he's been taking credit for
> ten years.
> (strong)
> I'm the only painter in the family.

Margaret slowly smiles.

And then . . . a calmness comes over her. Like a cloud has lifted.

INT. RADIO STATION HALLWAY—DAY

Margaret and Jane walk away. Jane beams proudly, then gives her mother a warm hug.

Then—LOUD CLICKING:

CUT TO:

INT. *NEW YORK TIMES*—DAY

John Canaday stands over a WIRE SERVICE TELETYPE MA-CHINE. He stares at a printout, incredulous.

> CANADAY
> You have *got* to be kidding!

INT. CHINESE RESTAURANT—DAY

TIGHT—The San Francisco Examiner. A small headline says "EYE DID IT! CLAIMS WIFE"

We PULL OUT, revealing Dee-Ann. She grins in disbelief.

> DEE-ANN
> I *knew* it!!!

INT. *SAN FRANCISCO EXAMINER*—DICK'S
CUBICLE—DAY

Dick Nolan reads the article—and SPITS UP his martini.

INT. HUNGRY I—DAY

Banducci CACKLES, terribly amused.

INT. ART GALLERY—DAY

Ruben SHRIEKS at the article.

> RUBEN
> Who would WANT credit?!

INT. COFFEE SHOP—DAY

Walter sits in his favorite haunt, eating lunch and reading a NEWSPA-PER. Suddenly—he GASPS.

> WALTER
> Holy mother of GOD!

Walter JERKS UP—feral—like an animal sensing danger.

He whirls and looks around. Paranoia ratcheting. Is everybody staring at him? Walter starts shaking in horror. Then—he jumps and BOLTS OUT.

INT. BAR—NIGHT

Walter sits with Dick. Walter's desperate, sweaty.

WALTER

Margaret's gone berserk! You gotta
help me! I need a story, a wire
story—*national!*—to calm things down.

Dick peers shrewdly.

DICK

I don't know . . . Walter. What she has
said is pretty inflammatory.

WALTER

But it's nuts! It doesn't even make sense.
When I was studying art at the Beaux Arts
in Paris, she was still a kid in Tennessee!

Dick reacts. Walter whips out the Tomorrow's Master's BOOK.

WALTER

Look! These are my early sketches.
 (*he flips pages, like a magician*)
See?! *Berlin orphans, 1946!*

DICK
 (*piqued*)
But . . . how could she . . .

WALTER

Exactly! It's impossible! We didn't meet
for another nine years! After she busted
her first marriage.
 (*he shrugs*)
Hell, she busted OUR marriage! Sleeping
around with whatever trash she could find!!

Dick's head is spinning.

———— • ————

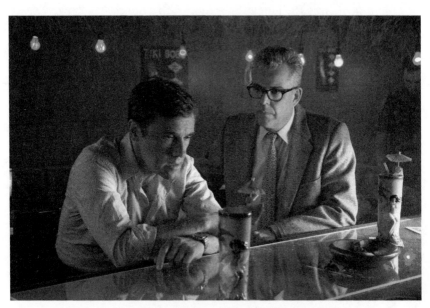

Gossip columnist Dick Nolan hears Walter's side of the tale.

———— • ————

 DICK

I—I, but . . . why would Maggie do this?

 WALTER

She's unhinged! She left me and moved
into the jungle. She fell in with a bunch
of religious zealots:
 (whispering)
Jehovah's Witnesses.

 DICK

I really don't know much about them . . .

 WALTER

Oh! These people are *gone*! Solid gone!
They don't celebrate Christmas, they can't
salute the flag . . . they won't even let
Janie go to the *prom*!

Dick is startled.

INT. HAWAIIAN HOUSE—DAY

*Margaret sits with a GROUP of her Witness friends. She is sorrowful.
Confused. Clutching ASSORTED NEWSPAPERS.*

 MARGARET

He made me sound crazy!!

 ASIAN LADY #2

Just rise above it.

 MARGARET

But how can I?! He claims I copied HIM!
That he taught ME how to paint!
 (reading the NEWSPAPER)

"She used a slide projector to trace my
work and fill in the colors."

 ASIAN LADY #1
And which part of that is untrue?

 MARGARET
ALL OF IT!
 (*impassioned*)
When I finally told the truth, I felt good
about myself for the first time in years!!
I'm not going to let him take that away.

Nobody is sure what to say. Until—Jane pipes up:

 JANE
Hey. Is Jehovah okay with *suing*??

 CUT TO:

EXT. HONOLULU FEDERAL COURTHOUSE—DAY

*The mighty courtroom steps are SWARMING WITH PEOPLE. It's a
circus. LOCAL TV NEWS CREWS do stand-ups:*

 REPORTER #1
Seventeen million dollars!
 (*beat*)
The art world is abuzz! Is it possible that the
decade's top-selling painter can't even paint??!

 REPORTER #2
Or is Mrs. Keane simply a bitter ex-wife, try-
ing to steal her husband's fame and fortune?
 (*beat*)
Today in Federal Court, lawyers present

their opening arguments in the case of
Margaret Keane vs. Walter Keane and Gan-
nett Newspapers. A trial that could produce
the largest libel and slander award in
Hawaiian history.

Margaret, Jane, Margaret's LAWYER, and her FRIENDS walk up.
Margaret glances over—and spots FEMINIST SUPPORTERS smiling
at her. They hold up signs: "Stand Up and Be Counted!"

Margaret is bewildered. She hurries in.

AT THE CURB

Walter and a POSSE OF LAWYERS exit a Town car. The REPORT-
ERS charge over, as Walter puts on a confident face.

> REPORTER #1
> Mr. Keane! Are you at all concerned about
> the charges?

> WALTER
> I'm angry as hell! But I'm lucky to have
> the mighty Gannett News Company
> watching my back. I expect to have this
> whole trial dismissed by noon.
> > *(beat)*
> Truthfully, my only concern is that some-
> body get this woman some psychiatric
> care. She needs it!

CUT TO:

INT. FEDERAL COURTROOM—LATER

The EIGHT JURORS watch attentively. Walter sits with the table of slick Gannett lawyers. The lead lawyer stands in front of the irritable Chinese JUDGE.

> GANNET LAWYER
> Margaret Keane is a public figure. And as
> such, she has to prove that our newspapers
> published statements, *aware* of probable
> falsity.
>> *(beat)*
> But there is no evidence that our editors
> could have known that the assertions were
> untrue.
>> *(beat)*
> We would like to submit 692 articles and
> interviews in which Mrs. Keane credits
> Mr. Keane as the painter of the so-called
> "big eye" children.

His Associate hands two massive bound PILES OF NEWSPAPERS AND MAGAZINES to the BAILIFF.

Margaret winces.

Walter grins, eating it up.

The Judge stares sourly at the piles.

> JUDGE
> How many years back do these go?

> GANNETT LAWYER
> Mrs. Keane has been making these state-
> ments since 1958.

Beat.

> JUDGE
> This is a very strange case. These paint-
> ings hang in museums all over the world,
> attributed to Mr. Keane. And regardless
> of the truth, Mrs. Keane has contributed
> immeasurably to the confusion . . .

The Judge stares off . . . then makes a decision.

> JUDGE
> It seems impossible that Gannett's actions
> would ever meet the legal standard for
> libel. So—the charge against them is
> dismissed.

WIDE

The Lawyer smiles, relieved.

> GANNETT LAWYER
> Thank you, Your Honor!

Walter peers, comprehending . . . and then, a realization slowly kicks in. His face turns to horror.

The Lawyer nods humbly, then spins away. He smirks at Walter.

> GANNETT LAWYER
> Good luck, Keane.

AT THE DEFENSE TABLE

The ENTIRE LEGAL TEAM jumps up and begins packing their brief-cases.

Walter sputters in astonishment.

WALTER

"Good luck"? W-where the hell are you
going?!

GANNETT LAWYER

We were charged with libel. You're
charged with slander.
(*blasé*)
Just dance your way out of it.

The Lawyers file out, leaving Walter alone at the table.

He looks very small and pale. The Judge peers quizzically.

JUDGE

Mr. Keane, you appear to be without
counsel. Would you like a postponement,
in order to get your affairs in order?

Walter glances over at Margaret. She stifles a laugh.

He glares daggers. Then, cocksure, foolhardy, he jumps to his feet.

WALTER

I've always taken care of myself, Your
Honor. And I don't need a bunch of rent-
a-suits to defend my good name!
(*beat*)
Let's PROCEED!

CUT TO:

INSERT—WIRE SERVICE TELETYPE MACHINE

Words type out: AP—HONOLULU—KEANE TRIAL TAKES
STARTLING TURN

INSERT—ANOTHER WIRE SERVICE MACHINE

More words type out: UPI—HONOLULU—HE'S A PAINTER. . .
AND A LAWYER?

INT. DICK NOLAN'S OFFICE—DAY

Dick frantically types at his typewriter.

> DICK (V.O.)
> I'm concerned about my old pal Walter
> Keane. The Hawaiian heat may have
> cooked his brain! The only thing he knows
> about courtrooms and lawyers comes from
> watching Perry Mason on television!

CUT TO:

INT. COURTROOM—LATER

Walter stands down front. Like a Broadway star, center-stage.

> WALTER
> I'm the sole creator of my art. This is my
> total life. My contribution to the world—

> JUDGE
> *Mr. KEANE!* I've told you, *you must ask the wit-
> ness questions*! If you're acting as your own attor-
> ney, you cannot make statements at this time.

> WALTER
> Oh. Right! Ah, sorry, Your Honor.
> *(beat)*
> It's hard to keep this all straight . . .

Walter gathers his thoughts—then turns to the WITNESS STAND. Sitting in it . . . is Margaret.

> WALTER
>
> Mrs. Keane. It seems impossible that you'd expect anybody to swallow your fantastic story—

> JUDGE
>
> MR. KEANE!!

Walter grimaces. He tries again, choosing his words.

> WALTER
>
> Mrs. Keane. You seem like a lucid woman. Reasonably intelligent . . . So how could you possibly have gone along with such a far-out scheme?

CUT TO:

We slowly MOVE IN ON MARGARET.

This is her moment. And then—quietly, she speaks.

> MARGARET
>
> I was forced into it. You had—

She stops, bothered by this awkwardness. She looks away from Walter, to the Jury instead.

> MARGARET
>
> *He* had me dominated. He would rant and rave if I didn't do what he wanted. I was afraid. I didn't see any option, so I went along. I felt very bad . . .

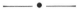

Margaret stands up to Walter in a Hawaiian courtroom.

WALTER
(*like a TV lawyer*)
I want to remind you, you are under oath.

The Judge SLAMS his fists down, enraged. Walter jumps.

WALTER
S-sorry.

Margaret turns back to the Jury.

MARGARET
I just gave in. I allowed him to take credit
for the Big Eyes. They reflected all my feel-
ings . . . and . . . it was like losing a child . . .
(*she sighs*)
I was weak. I didn't feel I could leave and
support myself and my daughter. He said
nobody would buy the paintings without
his personality.
(*soft*)
Maybe he was right . . .
(*to Walter*)
You were very talented at being charming.
You were a genius at salesmanship and
promotion.

WALTER
Hm! It sounds like you've described two
different men. One a sadistic ogre . . . and
the other a delightful bon vivant.

Margaret stares him in the eyes.

MARGARET
That's you, Walter. Jekyll and Hyde.

> WALTER
>
> What an *outrageous* statement! I demand
> we strike that from the record!

> JUDGE
> *(he SLAMS his fist)*
> Overruled!!

> MARGARET
> *(she loses her temper)*
> No! *You're* outrageous! Constantly criti-
> cizing! Wearing me down! Saying I'd be
> "knocked off" if I ever told the truth!!

The Jury GASPS.

Walter throws out his hands.

> WALTER
> Your HONOR! I ask for a mistrial!

Both Keanes starts QUARRELING. The Judge STANDS.

> JUDGE
> HEY! This is not a domestic squabble!
> Or—maybe it is. But the rest of us have
> no interest in watching you two go at it.

Walter calms himself, contrite.

> WALTER
> I'm sorry for the emotions. I'm an artist.

The Judge stares harshly.

> JUDGE
> Maybe.

IN THE BACK OF THE COURTROOM

Two SKETCH ARTISTS are busy, drawing the trial. One guy pokes the other one, to show off his work.

His SKETCH is a typical courtroom drawing, except everyone is drawn with big ridiculous Keane eyes.

The second guy GIGGLES. His buddy grins, then quickly erases the silly eyes before anyone sees it.

<div align="right">

CUT TO:

</div>

INT. COURTROOM—LATER

Margaret is back at the litigant's table, with her lawyer.

Walter stands, at his table. He shouts out.

> WALTER
> I call as my witness . . . Mr. Walter Stan-
> ley Keane!

A strange beat. The Jurors glance at each other.

Walter reacts, like he just heard his name. He strides jauntily over to the witness stand.

The BAILIFF gives the Judge a weird look. Then, he pulls out a Bible. Walter slaps down his hand.

> BAILIFF
> Do you swear to the tell the truth, the
> whole truth, and nothing but the truth, so
> help you God?

> WALTER
> YESSS!

Walter bounces out, a bit manic. He runs back to his lawyer table, then spins to address the empty witness stand.

> WALTER
>
> Mr. Keane. There has been a lot of innu-
> endo and contradictory testimony about
> the genesis of the "big-eyed waifs." Would
> you mind clarifying to this court, once
> and for all, who spawned these paintings?

Walter sprints back into the witness stand. He sits, then reacts coyly, as if he's surprised.

> WALTER
>
> Why—I created the children.

Walter starts to stand again—but the Judge SLAMS his bench.

> JUDGE
>
> The choreography is not necessary. Just sit
> down and testify.

Oh. Walter sits, then gathers his thoughts . . .

We slowly PUSH IN. He smiles, wistfully . . .

> WALTER
>
> I've had a wonderful life. I've been an
> artist, a world traveler, a friend of untold
> celebrities . . .
> > *(he gets misty-eyed)*
> But when I look back at it all, when I
> peer into my heart and define what mat-
> tered . . . it is that I was dedicated to the
> hungry children of the world.
> > *(genuine)*
> It all began in Berlin. After World War II . . .

 DISSOLVE TO:

LATER

 WALTER
 . . . the orphans were clutching the barbed
 wire. Their bodies lacerated, their fingers
 scrawny, their eyes big and helpless. Implor-
 ing me, begging me . . . "Do something!"
 (hushed)
 "Do something."

 DISSOLVE TO:

LATER

 WALTER
 . . . and then Miss Joan Crawford walked
 up to me . . .

LATER

 WALTER
 . . . Kim Novak . . .

LATER

 WALTER
 . . . Liberace . . .

LATER

 WaLTER
 . . . Wayne Newton . . .

LATER

> WALTER
>
> Miss Natalie Wood walked up and said,
> "That is the greatest single painting I have
> ever seen in my entire life."

The Judge is bored out of his mind.

LATER

> WALTER
>
> I was born in a small town. My father made
> upholstery for the automobile industry—

> JUDGE
>
> You're done.

Walter stops, surprised.

> WALTER
>
> B-but, I'm not finished—

> JUDGE
>
> Actually, you are!
> *(he blows his stack)*
> I cannot stomach one more wild tangent
> or shaggy dog tale. You're not testify-
> ing—you're filibustering! The Federal
> Courts are overburdened enough, without
> your docket-clogging nonsense.
> *(beat)*
> We can stay here until we grow old and
> die . . . but it's obvious that this case boils
> down to your word versus Mrs. Keane's word.

> WALTER
> (*hopeful*)

So . . . mistrial?

> JUDGE

NO! It's not a mistrial!! In my opinion,
there's only one way to clear up this
thicket. *You are both going to paint.*

Walter gasps, stunned. All color drains from his face.

ANGLE — MARGARET

Her face lights up. She slowly breaks into a satisfied smile.

> CUT TO:

INT. COURTROOM — LATER

*The doors SLAM open. The Bailiff leads in a crew of COURT DEPU-
TIES, all carrying ART SUPPLIES: easels, brushes, paint . . .*

> BAILIFF

Awright, bring those easels down. Careful,
don't bump anything . . . Watch it with
those paint cans, I got some newspaper on
the floor down front . . .

The Jury is fascinated.

Margaret watches, quite eager. In the gallery, Jane grins.

But Walter is horrified. Trying not to tremble.

DOWN FRONT

The Bailiff directs the deputies, setting up TWO EASELS, back to back. On each easel is placed a small square canvas.

The Judge addresses the room.

> JUDGE
> Now, I'm not looking for a mas-
> terpiece. I don't know much about
> these things—I'm a jurist, not an art
> critic—but, is one hour enough?

Margaret nods: Sure.

Shaking, Walter barely moves his head.

> JUDGE
> Okay then. You've both been provided
> with identical supplies . . . so—without
> any further business . . . Mrs. Keane, Mr.
> Keane, the court is yours.

WIDE

Margaret glances at Walter. What will he do?

Walter's face is grimly blank.

Margaret proceeds. Slowly, she pushes her chair from the table and rises.

Walter doesn't move.

Margaret walks over to the closest EASEL, then sits. She ties on a smock over her checkered dress.

THE JURORS

crane their necks, intently curious.

MARGARET

takes a pencil. She peeks over at Walter—who's still glued to his seat. His face tight, his expression queasy. Staring off to some faraway place.

Margaret looks up at the CLOCK. 3:20.

Okay then. Totally calm, in a motion she's done so many times, she focuses on the canvas and starts outlining a Waif.

Everybody watches. Effortlessly, she pencils the EYES. They are enormous. The largest orbs she has ever done.

WALTER

looks ill. Wracked with uncertainty.

The Judge turns to him.

> JUDGE
> Mr. Keane?

> WALTER
> *(faint)*
> I'm . . . setting the mood.
> *(whispering)*
> Getting the . . . muse to strike . . .

> JUDGE
> *(beat)*
> Well, your muse has 58 minutes.

MARGARET

fills in more detail. Ears . . . nose . . . then, little fingers clutching a fence. The child is peeking over it, staring right at us . . .

WALTER

is melting down. In total crisis . . .

THE CLOCK'S

second hand sweeps around. It's 3:34 . . .

THE JURORS

look from Margaret to Walter. Why isn't he moving??

MARGARET

finishes penciling. She leans back, satisfied with the composition. Then, she reaches for . . . the PAINT.

She unscrews a tube and squirts it on the palette. She rests it on her lap and starts mixing a flesh tone . . .

THE JUDGE

gapes at Walter, befuddled.

WALTER

feels all eyes on him. He has to do something.

Hesitantly, visibly shaking, he rises from the table.

Margaret notices this.

Walter braces himself, trying to look confident, then takes a step. Suddenly—he SQUEALS.

<div align="center">WALTER</div>

OW!

Walter contorts his face in AGONY.

He grabs his shoulder.

JUDGE
Mr. Keane! Are you all right?

WALTER
No—it's—
(grimacing)
Ah shoot! My old shoulder injury just flared
up. I've got a bad muscle—I've been taking
medication for the inflammation . . .

Walter shrugs pathetically—

WALTER
I—I don't think I'll be able to paint
today.

THE JUDGE

is astonished.

WIDE

The courtroom reacts.

MARGARET

peers at Walter, knowingly.

She's not surprised. This was his only way out.

*A look between them—and then she cocks a half smile and turns back to the
canvas. She squirts out some white oil paint, then begins painting the eyes.*

WALTER

sinks down in his chair, beaten. All life gone.

He stares at the emerging canvas, eyes wide, and we PUSH INTO WAL-TER'S FACE. He is witnessing the end of his empire . . . the destruction of everything that makes him who he is.

We push in TIGHTER . . . TIGHTER . . . until the screen fills with his two eyes.

Big. Sad. And filling with tears.

CUT TO:

EXT. FEDERAL COURTHOUSE—DAY

The doors open, and Margaret comes tumbling out, victorious. She has WON!

She's surrounded by Jane, her friends, and a MOB OF REPORTERS. They all SHOUT: "Mrs. Keane! Margaret! Congratulations!!"

MARGARET
Thank you! Thank you so much.

REPORTER #2
What are you going to call the painting?

She smiles, clutching the finished Waif.

MARGARET
"Exhibit 224."

They all ROAR with laughter. A Reporter does a stand-up:

REPORTER #1
The jury found in favor of Margaret Keane
on all points. She won on charges of
defamation, emotional distress, damaged
reputation—

IN THE BACKGROUND

Walter drifts out, disheveled and lost. He stares hazily . . . angrily at the crowd.

> WALTER
> What a group of idiots . . . a quagmire of
> incompetence . . .
> > *(rambling)*
> This doesn't change a thing!

We slowly PULL AWAY, leaving him tiny in the shot. Forgotten.

BACK AT MARGARET

She hugs Jane. The Reporter jumps in.

> REPORTER #2
> Margaret! Do you feel vindicated by the
> high award?

> MARGARET
> Oh . . . it was never about the money. And
> honestly—I doubt Walter will even pay.

The Reporter chuckles. Margaret turns serious.

> MARGARET
> I just wanted credit for what I had done.
> The justice is . . . I got my art back.
> > *(soft)*
> My prayers have been answered.

Margaret takes Jane's hand and starts to walk away.

Among the eager fans, a PORTLY LADY steps out, holding a BOOK. She smiles nervously.

> PORTLY LADY
> Margaret! Could I possibly have your
> autograph?

Margaret looks down—and realizes the book is Walter's volume of TO-MORROW'S MASTERS.

Margaret stares at it in wonder, then quickly signs the cover.

CLOSE-UP—MARGARET

We hold. She slowly smiles in pride.

DISSOLVE TO:

INT. MARGARET KEANE GALLERY—DAY

A brand-new gallery of Margaret's art. The walls are covered with NEWLY PAINTED Waifs and MDHs. We GLIDE through the gallery . . . down the corridors of children and women . . .

These paintings of big-eyed children are different. They're in magnificent colorful gardens, surrounded by joyful splashes of red, orange, green . . .

CLOSING CARDS:

> "Walter never accepted defeat, insisting he was the true artist for the rest of his life. He died in 2000, bitter and penniless. He never produced another painting."

> "Margaret found personal happiness and remarried. After many years in Hawaii, she moved back to San Francisco and opened a new gallery. She still paints every day."

We move CLOSER to one child, into the face, until the eyes fill the frame. And then . . . finally, we tilt down. Revealing that the child is smiling.

FADE OUT.

THE END

———•———

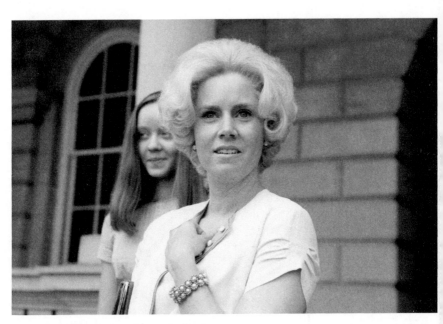

Margaret outside court, victorious.

———•———

Behind the Big Eyes

The Story Behind the Film

The fact that you are holding this book in your hands represents some sort of miracle. The fact that this movie got made—that it actually exists—is beyond belief. In recent years, it has been more and more difficult to get dramatic, hard-to-categorize movies produced. Hollywood is littered with tales of films that "took forever." But *Big Eyes* is unusual, in that the crazy people who wouldn't give up were the screenwriters. No studio was there to help us. Nobody ever paid us. For ten deranged years, we were the only guys who had a dog in this fight. We believed and believed in this project—sometimes to the point of madness. It got self-destructive—there were so many jobs we said "no" to because we thought we were about to shoot our movie. It was always around the corner, always being prepped, with a new producer, a new cast, a new mirage of cinematic hopes and dreams. But we loved the story, we loved the characters, and we just couldn't sensibly walk away. We wanted to see this tale of Margaret and Walter Keane on-screen.

Why? What compelled us? What about this story wouldn't let us go?

In the nineties, we were lucky to have written a run of biopics that deconstructed the typical Hollywood bio. These weren't stories of Great Men. Ed Wood, Larry Flynt, and Andy Kaufman were nuts who were outsiders and shook up the establishment. This seemed like a new form of biography—celebrating obscure iconoclasts. We gleefully wallowed in this strange new hybrid we had invented. It was so much fun! But then we had a few scripts not get produced, and the momentum stopped. We started falling back on script assignments, which is another way of saying we had families and mortgages, and we had to pay the bills. It's nice to dream big, but it's also nice to put food on the table.

In 2003, we were rewriting a science fiction movie. It was a comedy that took place on another planet, and we needed examples of Earthling pop-culture kitsch that could destroy a higher civilization. In our research, we stumbled across a two-page article about the Keanes that took us aback. *Whoa. What's this?* The Keanes's story was bonkers.

In their heyday, the 1950s and '60s, the Keanes were the top-selling artists in the world. Their big-eyed art was everywhere. But their personal story was an utter fraud: Walter claimed to be the painter, but the true talent was Margaret, despondent, locked in a room in the back of the house. This lie went on for more than a decade!

This was a great untold story, which is our favorite kind. We love pieces of Americana that happen in the margins. Everybody knows the sad-eyed images, but nobody knows where they came from. And certainly nobody knows the pain behind the paintings. The story was crazy—and we were hooked. *This could be a biopic.*

We leapt into research mode. We spent a few weeks in the UCLA Research Library, scrolling through microfiche from the old *San Francisco Chronicle*s and *Examiner*s. The Keanes were society-column stars up there, and we found tons of coverage. We read old *LIFE* magazines. We found a *Mike Douglas Show* appearance from 1972. Our friend, rocker Matthew Sweet, is a rabid Keane collector, and he gave us access to his collection of Keaneabilia. The story wrapped up in a Hawaiian courtroom, and we tracked down the coverage from the Honolulu papers. We loved it all. Usually movies about artists are stuffy and pretentious—but this one could be funny!

As we organized the material, we came to a dawning conclusion: Walter was the showboat, the obnoxious, funny, outsized type of personality we love. But . . . Margaret was the character with the journey. Even though Walter does most of the talking, we decided to make Margaret the protagonist. This was a big decision for us, as we had never told a bio script from the woman's point of view. We realized we could shape the story to parallel the women's rights movement: Margaret starts out as a repressed 1950s housewife and ends as a liberated 1970s woman. By the climax, she has the courage to speak up and tell the truth.

The story also fed into themes of high art and low art, which always fascinate us. Like Ed Wood, Margaret and Walter were outsiders, blocked by the artistic community gatekeepers. In the Keanes's case, they couldn't get past the fancy art galleries and withering press critics. They were terribly out of step. Modernism was in vogue, and abstract art was incomprehensible to Walter. He would rage against these phonies. To Walter, art was a bowl of fruit. We were giddy with the idea that we could make a satiric movie that debates "good art" vs. "bad art," and whether such a distinction even exists. If the crying

children provoke emotion, aren't they valid? And more intriguingly, does the revelation of the real story make them more "legitimate"?

In their time, the paintings were accused of Extreme Kitschiness because the artist supposedly was Walter—masculine, cocky, with a strong drink in his hand. Why on earth would this man be painting little crying children? But once you knew the truth—that Margaret was the artist—the art was suffused with great meaning. Quite simply, it was a sad woman expressing her feelings.

After all our research, there was still too much we didn't understand. Why had Margaret made these choices? Why had she allowed this lie to go on for so long? What had she known, and when had she known it? The public story didn't answer these questions. Walter had died, but Margaret was still alive and still painting. We realized we had to track her down.

In the summer of 2003, we flew up from Los Angeles to meet Margaret in a rural area outside San Francisco. Like high schoolers studying for a term paper, we memorized every aspect of the Keane saga so that she would know we were serious. She is very private, and we had to win her over. We wanted her life rights, as well as the rights to use her art. This was a big mountain to climb.

Over a very long lunch, Margaret opened up. Incredibly, her key concern was that people might watch the movie and think that Walter was the painter. This concept blew our minds. How could *anyone* still think that? Margaret had won in court. Walter hadn't produced any paintings in the thirty years after their divorce! Margaret still produced new paintings daily. Yet, like the abused wife she was, she still feared that Walter's PR spin would win in the court of public opinion.

The lunch also revealed a side of the story that we had known

nothing about. During the years of deception, Margaret had been lying to her daughter, Jane. The three of them had lived together, and it had been patently obvious, even to a child, that Mom was in the painting room all day. Walter might blow in and out with his "new" painting, but Mom was clearly the artist. But Margaret was forced to lie to Jane's face for a decade. Jane knew she was being deceived. Margaret could see it in Jane's eyes, and this was heartwrenching to her. It was the biggest regret of her life. The person she was closest to in the world knew she was being lied to. It created a terrible gulf between them. This was very sad and touching, and we realized this would become the emotional center of the movie.

Margaret also described how the arrangement with Walter took over her life. The situation became like Watergate, where the cover-up was worse than the crime. Incredible amounts of energy were expended in keeping the "cover story" viable—that Walter was the painter. Back then, people didn't have Google, so it was easy to adjust the lies over the years without getting caught. The details were fascinating and horrific. Margaret described how Walter wouldn't allow her to have friends—because friends might want to come to the house. Or Margaret might slip up and confide in one. So he isolated Margaret more and more.

Margaret also described the personal happiness that came from her becoming a Jehovah's Witness. She asked if we could put this in the movie. She said it was the most important thing in her life. Living as a Witness had given her the courage to live honestly—and honesty had meant outing Walter as a fraud. We glanced quickly at each other—we hadn't planned on having religion within the film. However, in an unspoken decision, we figured there was a way to make this element dramatic and organic to the story, and so we said yes.

By the end of the afternoon, we were all laughing and carrying on like old friends. Margaret could see we were simpatico with her. We had earned her trust. Yes, we could option the rights. We finished with hugs good-bye and promises that we would make a deal, write a script, and do her proud. We were off to the races!

On the flight home, we were drunk on all the insight and details we had learned. That one visit inspired the majority of our supporting cast. Jane was clearly a major part. Margaret's tales of friends pushed away created the composite character of Dee-Ann, the girlfriend who starts to figure out the ruse. And Margaret's constant references to Dick Nolan, a gossip columnist whom Walter befriended, made us realize that Nolan was a major player in this story. He had helped make them famous. We realized that Dick was all over our notes from the microfiche. Adding him to the story delighted us, as he reminded us so much of the characters in *Sweet Smell of Success*, a movie we loved. That 1957 movie is all about jazz nightclubs, newspapers, and the desperate hustle for fame. With that world clear in our minds, we envisioned our movie. We knew we could jump into this confidently.

When we met Margaret, she was seventy-five. Our goal now was to write an intimate drama that we could direct ourselves, on an independent budget. In old-school parlance, it would be a "two-hander"—a story about two great characters that would attract two great actors. We funded all development out of our own pockets, as we believed so strongly in the material. By 2006, we had a script we were happy with. By 2007, we had a cast, crew, a budget, and $12 million in financing. Margaret was so excited!

But then, the stock market crashed. Financing sources dried up. Margaret was disappointed. Undeterred, we relentlessly

kept reconfiguring the movie, recasting, at various times planning shoots in Los Angeles, Portland, Salt Lake City, New Orleans, even Buenos Aires! Each one of those false starts represented months out of our lives. New schedules and budgets, new scouts, new crews. Years of our lives were expended looking for the perfect mid-century modern house for Margaret and Walter to live in, our search spread across the United States, parts of Canada, and South America. More than half a dozen producers cycled through, with promises that all collapsed. The budget kept dropping. Unwilling to concede defeat, we brought in a new producing partner, Lynette Howell, who came from the world of scrappy indies. Lynette helped us rethink the movie as something smaller, but the film remained a period piece in 1960s San Francisco, never a cheap story to tell. At one point, we got so desperate that we looked into financing from characters out of a Nigerian e-mail scam—but even they fell through!

We brought in Tim Burton as a producer, because he is a Keane collector and a fan. We thought that Tim's involvement would help make the film happen. But still, no. Actors and actresses kept approaching us about the script, so that gave us hope, reassuring us that we weren't insane to keep chasing this dream. So many years went by that we had to keep extending our rights deal with Margaret. Eventually the extensions ran out, and we had to write a new deal. It was ridiculous. Margaret was patient, but not getting any younger. Every few months, she would call: *Are you ever going to make our movie?!* We were guilt-ridden! Margaret was now in her mid-eighties. Still no film!

Finally, in early 2013, a phone call came in. Would we be interested in making the film with Christoph Waltz? Wow. What a spectacular idea. We e-mailed Tim and asked

his opinion, and he immediately responded enthusiastically: YES! *He's Walter!* And suddenly . . . we had an epiphany. We should hand off the film to Tim. He was the only director in the world we would entrust our Keane project to. At this point, a decade had passed without results; we just needed this movie to see the light of day. We had had a fabulous experience with Tim on *Ed Wood*. He had shot our first draft, and he did an impeccable job with the look, tone, and performances. We knew he would nail this one, too. So we pitched our scheme to Tim. His producer Derek Frey was highly encouraging—feeling a smaller movie would be an artistic palate cleanser for Tim. A day passed . . . and Tim bit. He was in. We would produce, and he would direct.

Tim met with Christoph. A few days later we were all in a casting meeting. By the end of that week, our first choice, Amy Adams, was cast. Harvey Weinstein stepped in to finance, and suddenly we had a green light and a start date! Friends called to congratulate us: *We can't believe how quickly you put this movie together!* We laughed, dumbfounded. *Quickly?! It's been ten years!*

In July 2013, we started filming. We tried to include Margaret in the process. We arranged for Amy to meet Margaret, and they spent a happy day together, with Margaret tutoring her in brush technique. Amy was assuredly studying Margaret the whole time, storing her away for her performance. During production, we could afford a grand three days in San Francisco, and we brought Margaret to those sets. It was like magic—suddenly she was standing in North Beach in 1958 again. She was staggered by the detail of the art direction. The film wrapped and went into extended postproduction. Finally, in the middle of 2014, we started pushing everybody to let us show Margaret the film. Tim was still tweaking his final touches, but it was hugely important to us that she get the

opportunity to see it. She had waited so long! For goodness' sake, she was almost eighty-seven! Everyone agreed, and on a glorious summer day, we flew back up to San Francisco, just like that day eleven years earlier, to meet Margaret. But this time, we had a film to show her. Margaret brought Jane and her family. Our tiny group sat down in the plush theater at Skywalker Ranch, and the film started rolling.

We sat behind Margaret and Jane, so we could watch their faces. A few scenes in, a Sunday art show appeared, with young Margaret and eight-year-old Jane in the park. In the theater, we could see the real Margaret and Jane nudge each other in recognition and grin, delighted. They remembered the moment. At other times, the film turns very sad, and it made Margaret weep. But when it was over, she just sat there in joyful disbelief. She was very happy with the movie. We came over to her, and we all hugged. The long journey had been worth it.

— SCOTT ALEXANDER & LARRY KARASZEWSKI

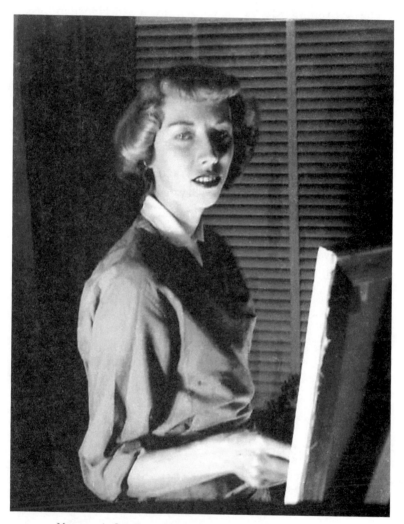

Margaret in San Francisco apartment, 1958

Margaret Keane Looks Back

An Interview

by Tyler Stallings

MARGARET KEANE: I met Walter Keane at the San Francisco Art Festival. I was doing charcoal portraits for five dollars. Walter walked by and kind of swept me off my feet.

INTERVIEWER: *And about how old were you both at that time?*

MARGARET: I was twenty-eight. I think he was twelve years older. And he certainly acted like an artist. He wore a beret and had a wonderful personality. He charmed anyone. We ended up getting married. He was in the real estate business although he was painting on the side. He wanted to be an artist so bad and give up on real estate. So he started to try to sell his street scenes and my portraits.

INTERVIEWER: *At an art fair?*

MARGARET: Yeah, we would go to art fairs. Then he took my Big Eyes paintings and his street scenes and put them in the hungry i canteen.

INTERVIEWER: *Can you describe what the hungry i was?*

MARGARET: It was a nightclub/bar, a very popular place, and that's where Phyllis Diller got her start, and the Kingston Trio. Walter was really part of the scene down there, entertaining everybody. I was home painting, and he was down there selling.

INTERVIEWER: *And how were you signing paintings at that time?*

MARGARET: At that time, I just put "Keane" because Margaret is so long. He had "Walter Keane" on his street scenes. So this went on for a couple of years, but I didn't realize he had been telling people he did all of them. And the children with the big eyes were selling better than the street scenes! Then we had a big controversy one night with Enrico Banducci, the owner of the hungry i. They got into a fistfight over some woman who was sitting at the bar. And somehow she got hit, accidentally, I think. It was this big thing that was on the front page of the paper, and they had a trial, and it was just farce. I don't even know what the outcome was, but we couldn't hang the paintings at the hungry i anymore, because Walter and Banducci weren't speaking. So he found a space above Vanessi's restaurant on Broadway.

INTERVIEWER: *What year was this?*

MARGARET: This was 1956 or 1957. So he opened this gallery and we wanted to do some posters. We'd staple 'em or glue 'em to fences, telephone poles, houses, anywhere, everywhere we could think to put 'em. And we'd go by the next day and they'd all be gone! We were so upset—we didn't know who was taking the posters. Then in the gallery we would give them away, and when that got too expensive, we started selling them and we couldn't print them fast enough. People were just loving them and it was

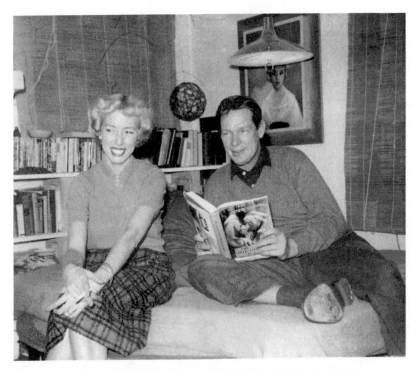

Walter and Margaret newly married, Berkeley, California, 1957

snowballing. It was about this time that I found out that he was telling people that he did my paintings. Then one day, I was in the gallery and I was unpacking everything . . . and I found this bottom box, this great big, huge box. I was curious about what was in that. I opened it up and in it were all these Paris street scenes with the name Cenic. C-E-N-I-C. I immediately realized that he hadn't done any of these street scenes. This man, Cenic, did them.

INTERVIEWER: *Was that a teacher of his or something?*

MARGARET: Well, he claimed that it was his teacher. I think what [Walter] did was take [Cenic's] name off and put his name on. So this was a nightmare for about ten years. It was just a terrible nightmare. Of course he had me believing it was my fault that he couldn't paint. I really was like . . . not physically abused but emotionally and psychologically abused, to the point where I was afraid to open my mouth in public. If I did, when we got home he'd rant and rave and say, "Why'd you say that" and "You should just keep your mouth shut." It was pretty bad. Anyway . . . I'm a survivor.

INTERVIEWER: *Just to summarize, you got divorced in 1965?*

MARGARET: I finally got the strength to leave, and I said, I gotta put two thousand miles between us.

INTERVIEWER: *And then after that, he still claimed ownership. Eventually you had to take him to court?*

MARGARET: The lawyers just decided that the only way to make him stop was to sue him. So I sued him and that case is the one where I did this painting in court and won the unanimous jury decision, that I was the artist. But I just want to say . . . Walter

was a genius at promotion, and I feel sorry for him, because he wanted so much to be an artist. He was extremely talented in what he did. He took those paintings and made them well-known because of his talent. I really think he deserves a lot of credit there.

INTERVIEWER: *Let's just jump back: Could you tell me about when you first got started painting and the use of your daughter as a model?*

MARGARET: You want me to go way back to the beginning? Well, I remember that I was always drawing, and in the first grade the teacher told my mother she thought that I had talent. So my mother encouraged me, and I had an uncle who encouraged me. After school, when I was about ten, I started taking art lessons at the Watkins Art Institute in Nashville. And I was the youngest one there. Most of [the students] were in their teens, and they were drawing these wonderful pictures. I wanted to be able to do what they were doing, and I couldn't, at that age, but it made me want to do it. I just always knew I was going to be an artist. I wanted to go to New York and study art, and I finally got there after high school. I first got a job typing and went to art school at night. Then I got married and got sidetracked a little bit, and when my daughter was a baby, I started drawing her picture. When she was about two, I think, I did my first oil painting of her. Some of my friends who had kids, they wanted me to do their children. So pretty soon I was doing quite a lot of portraits, and on all of them the eyes were big. I think when you look at a child, you notice the eyes are big. That's kind of how the eyes started. Then I wanted to do faces and not have to make it look like a particular child, I wanted just an imaginary face—and then the eyes were even bigger in those. I didn't realize it at the time, but what I was doing was painting my own inner feelings and expressing them through a child.

Margaret and Walter in Hawaii, 1958

INTERVIEWER: *A lot of your early paintings were what {the art world} called the waif paintings. Can you tell me about those?*

MARGARET: I started doing them to relax and to do something for myself and not have to please the sitter or the parents. I would do these sad kids because I was sad. And I was putting my feelings into them. Even though they were sad, I think they had hope. They were looking for answers . . . and I was looking for answers. You know, "Why are we here?" "Why is there suffering?" "Why is there injustice?" And then, when Jane was growing up, I would often use her as a model, but I would change it and make the eyes larger to express more what I was feeling. A lot of people think the eyes are the windows to the soul, and I think they express our inner feelings. I've also been interested in spiritual things. Deep philosophical things. So I think that comes out. And I really love children's art. What's important to them is the big thing—they make it larger, way out of proportion to reality sometimes. I think that's why the eyes got bigger. I didn't do it consciously and I didn't realize till later why I had done it.

INTERVIEWER: *When you did some of your commissions, what was it like to paint someone like Natalie Wood?*

MARGARET: Natalie Wood was a perfect model. It was a challenge because she was so beautiful. I couldn't in any way flatter her, because she was already so perfect. I've never had anyone sit so still. I commented on it, and she said she had been posing since she was five, so she knew how to sit just perfectly still. So while I was doing her, someone was doing her fingernails, someone was doing her toenails and someone else was doing her hair. But she was sitting there perfectly still while all these other things were going on. I think the first day she sat about six straight hours! That's why I think it came out so good. And then later, I did Robert Wagner's portrait.

INTERVIEWER: *And how was that?*

MARGARET: It was good, too, but hers was better. I like painting women better than men for some reason. I don't know why—maybe I relate more to women. I don't paint too many men. Once in a while I'll do little boys. My painting that I did of Joan Crawford, she put on the cover of her book. She collected many of my paintings. She probably had twenty or more, and she loved them. When she found out the truth about who actually painted the paintings, she was just wonderful to me. She was a wonderful friend, and I don't believe a word of what her daughter said about her.

INTERVIEWER: *She put your paintings in her film* Whatever Happened to Baby Jane?

MARGARET: Yeah, I painted her little dog, too. One summer, I spent about two months in Beverly Hills painting the Jerry Lewis family. I stayed at the Beverly Hills Hotel, and every day in the poolhouse I'd set up my easel. Their plan was to have the butler bring in one child at a time for about a thirty-minute session, then take that child away and bring another one in. In the beginning, they were reluctant. Five boys, four dogs, and three cats, but after the first hour or so they got intrigued with it and they didn't wanna leave when their turn was up. So I ended up with all of them in the room, chasing cats and dogs and kids, just total bedlam. But it was fun.

INTERVIEWER: *Can you tell me about painting Liberace?*

MARGARET: I did his painting in the middle of the lobby at the Royal Hawaiian hotel in Honolulu. When he said he wanted me to do his painting, I thought he would want to be painted in his room. But he said, "No, I want it painted in the lobby."

So this just totally floored me. I had to sit there and paint him with about three hundred people standing around watching. And he was talking and laughing and moving around. It was a little difficult, so when I got ready to do his mouth, I asked him to please, just for a minute, close his lips and stop talking. He said, "If you have pretty teeth, you should show them." So I put his pretty teeth in the painting.

INTERVIEWER: *What kind of paint do you use? Is it strictly oil, versus acrylic?*

MARGARET: I usually just paint with oil and nothing else, straight out of the tube. Sometimes I'll put in an acrylic background, rarely. If I'm trying to do something fast and want it to dry fast, then I might paint acrylic first and then go over it with oil.

INTERVIEWER: *Do you ever just draw?*

MARGARET: Yes, I like to draw very much. My favorite medium is oil and pencil and colored pencils. And I do a lot of mixed mediums—mixing up pastel, pen, and ink. I'm a very fast painter. I probably shouldn't tell you how fast I paint, but I can when I have to. Like in the court, when I did that painting, in front of the jury and the judge, big eyes, little nose, and a mouth. Just that much took one hour, but that's the fastest I ever painted. Normally it would take me two or three, four hours to do that much.

INTERVIEWER: *Do you have certain influences, like Modigliani?*

MARGARET: Yes, I love Modigliani's paintings and I really studied them and looked at them and copied them. Yeah, he has really influenced my work a lot.

Margaret at the Keane Gallery, San Francisco, 1961–1962

INTERVIEWER: *How do you feel about contemporary artists adopting some of your eyes?*

MARGARET: Well, I'm flattered. It doesn't really bother me too much. I'm glad they like my paintings enough to do it. It does disturb me when they'll really try to copy it exactly and maybe even sign "Keane" on it.

INTERVIEWER: *What do you think about a lot of current pop stars collecting your work? Can you talk a little bit about that?*

MARGARET: I'm surprised. I'm happy when people like my work. I don't quite know exactly why they like it, but I'm glad they do. Maybe they're searching for answers and the paintings say something to them. I think they like the older ones better than the recent ones.

INTERVIEWER: *How do you feel about that?*

MARGARET: Well, when someone likes the older ones, I'm pretty sure that they have the same type of feelings that I had when I painted them. They're wondering, Where is the world heading, what's happening, and why am I here? And I guess that this generation is feeling the same things that we did in the sixties. Pop stars like Matthew Sweet and others seem to like my paintings, which is very flattering to me. I don't exactly know why. I think the world situation today . . . Everything is so insecure and [there's] so much injustice in the world that people are looking for something better. I think the hope for the world is God's Kingdom, which will establish Paradise condition again, the way it was meant to be. I think young people today are searching for these things. And that must be why they like my paintings.

INTERVIEWER: *How does it make you feel, that people find answers in your paintings?*

MARGARET: That makes me feel very good, that I was able to paint something that they could relate to, and it might help them come to grips with their own feelings. And maybe they'll find the same answers that I found in the Bible. That's what I really hope. I think each person has to do their own searching. You know sometimes when people interview me, they don't want me to talk about my spiritual beliefs. They'll say, "You know what, Margaret, this is not a religious article." But my religious beliefs are why I paint the way I paint . . . really tied in very closely. My deepest thoughts and feelings and my relationship with the Creator is the most important thing in my life and it comes out in my paintings.

———

Tyler Stallings was chief curator at the Laguna Art Museum in Laguna, California, for the *Margaret Keane and Keanabilia* exhibition. He is currently Sweeney Art Gallery director at the University of California, Riverside.